L. E. Stock.
Manchester,
May, 1977.

CONCISE CATALOGUE OF BRITISH PAINTINGS

Volume I

British artists born before 1850

Manchester City Art Gallery

1976

Cultural Committee 1975/76

The Right Worshipful The Lord Mayor
Councillor Dame Kathleen Ollerenshaw, DBE

Chairman
Councillor H. Conway, JP

Deputy Chairman
Councillor R. W. Ford

Councillor D. Barker
Councillor N. I. Finley
Councillor G. W. G. Fitzsimons
Councillor K. McKeon, JP
Councillor Mrs B. Moore
Councillor Mrs D. M. Mountford, JP
Councillor H. Platt
Councillor L. Sanders
Councillor Mrs S. V. Shaw
Councillor R. E. Talbot
Councillor M. J. Taylor
Councillor Mrs S. R. Tucker
Professor B. Deane, BA, PHD
Professor C. R. Dodwell, MA, PHD
Mr H. M. Fairhurst, MA, FRIBA
Mr C. Paine, BSC, FRIC, FSDC
Professor J. E. Prudhoe, MA(Cantab)
Dr F. W. Ratcliffe, MA, PHD
Lady Worthington, MA, ARCA

Principal Officers

Director of Cultural Services
L. G. Lovell, FLA

Director of Art Galleries
G. L. Conran, MA, FMA

Published by the City of Manchester Cultural Services
Designed and printed in Great Britain by Lund Humphries
© 1976 City of Manchester Cultural Services
ISBN 0 901673 07 2

FOREWORD

The collection of Fine Art at the Manchester City Art Galleries has grown tremendously since 1910, the date of the last published paintings catalogue. The range and depth of the collection has been considerably extended by gift, bequest and purchase and the more recent creation of the Art Fund has made possible the acquisition of works of the highest quality and importance.

Sadly, much of the collection has scarcely been seen because of the lack of space, and the main displays have always been split up between the City Art Gallery and its branches. An illustrated catalogue such as this will at least demonstrate the riches of the collections to which the present display arrangements cannot do justice.

This summary catalogue is the first result of a programme initiated some years ago, to take an inventory of the collection, recording information to modern requirements and photographing each work. Further volumes will be issued to cover all the oil paintings and sculpture in concise catalogue form.

This work is the prelude to a more lengthy programme of research leading to the publication of full catalogues. It was, however, felt that it was better to bring out the present volume now, as it was already a useful work of reference, rather than delay publication until such time as full entries have been prepared. The attributions given here represent present opinion, though some works are given under traditional attributions which may well be changed as research progresses. It is hoped that this publication will bring some of the lesser known works to a wider audience, and that this will aid future research.

The preparatory work has been carried out by the staff of the Gallery over a number of years. The entries for the present volume have been collated by Julian Treuherz, Keeper of Fine Art and J. Selby Whittingham, Assistant Keeper.

G. L. Conran
Director

NOTES

The concise catalogue of British paintings is divided into two volumes according to whether the artist was born before 1850, or in or after 1850. All works in oil or in tempera in the collection are included, except for loans. A further volume to cover the Foreign Schools is also planned.

The British collection contains many works by local artists and these are included except for topographical paintings of purely documentary interest. These are part of the separate Old Manchester collection.

Arrangement of entries

Works are arranged by artist, in alphabetical order. Where there are several works by one artist these are given in accession order for each artist. The only exceptions to this are the unattributed works under 'English School' which are arranged in approximate chronological order.

Attributions

Artist's name
The work is by the artist in question. This judgment is based on firm documentation or on style. In some cases traditional attributions are adhered to even when they do not rest on firm evidence, because no reasonable alternative has been put forward.

Attributed to
The works may be by the artist in question but doubts have been expressed about the attribution.

Follower of
The work is not by the artist in question, but is by an artist working at roughly the same period, in a style close to that of the master.

Manner of
The work is not by the artist in question, nor necessarily of the period, but is in the artist's generic style.

After
The work is a specific copy of a painting by the artist in question but could be of any date.

English School
The work does not correspond to the style of any particular artist.

Former attributions
These are given in every case to aid identification.

Titles

Alternative and former titles are given in brackets to aid identification, but the more authentic or accurate titles are given first. In some cases titles have been changed back to those under which works were first exhibited, and in others more precise titles have been given to replace vague ones, such as 'Landscape'.

Dates

The date of the work, where known, is given on a separate line. In the case of portraits, the sitter's dates are also given, where known. If the work can be securely dated by documentary evidence, its date is given on its own. Otherwise abbreviations are used:

c. *circa*, for approximate dating on stylistic or other grounds

exh. date when first exhibited

engr. date when first engraved

b. born

m. married

d. died

Dimensions

Works have been re-measured for this catalogue. Sizes are given in centimetres, and followed in brackets by inches to the nearest sixteenth. Height precedes width. Dimensions given are those of the original painted surface, not of any additional supporting canvas, panel or mount. In a few cases works awaiting restoration are too fragile to be removed for measuring and here approximate figures are given from old measurements.

Signature and inscriptions

These are recorded in full:

s. signed

inscr: inscribed, for inscriptions in the artist's hand

(blc) bottom left corner

(tr) top right, etc.

(mon) following a signature, denotes that the initials form an artist's monogram

Signatures and inscriptions are given in italics. An oblique stroke is used to indicate the beginning of a fresh line in an inscription.

Provenance

Only the immediate source of each work is given. The date of accession to the gallery forms in most cases the first part of the accession number, given in brackets at the end of the entry. If the date of accession is different it is given separately.

Illustrations

In a few cases works awaiting restoration cannot be photographed and no earlier illustration exists; otherwise all works are illustrated.

Appendices

A number of miscellaneous portraits in the possession of the gallery came to Platt Hall with gifts or bequests of costume. These have been listed separately in Appendix I and have not been illustrated, as they are not of high quality or interest. Appendix 2 relates to those works transferred from the Royal Manchester Institution in 1882, and Appendix 3 lists works no longer in the collection which were included in the 1910 'Handbook'. Appendices 4 and 5 are indices of portraits and of donors.

CONCISE CATALOGUE OF BRITISH PAINTINGS

Joseph Allen
*c.*1770–1839

DR CHARLES WHITE (1728–1813)
Manchester surgeon
engr. 1809

Oil on canvas
76·2 × 63·2 (30 × 24⅞)
Unsigned
Lloyd Roberts bequest (1920.522)

PETER CLARE (1781–1851)
Manchester clockmaker and Quaker

Oil on canvas
76·7 × 64·6 (30 $\frac{3}{16}$ × 25 $\frac{7}{16}$)
Unsigned
Purchased (1927.41)

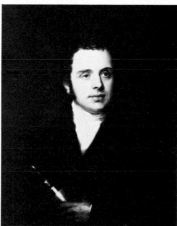

ST FRANCIS AT DEVOTION

Oil on canvas
92 × 71·7 (36¼ × 28¼)
Unsigned
Dr. E. J. Sidebotham gift (1927.50)

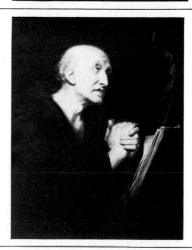

HANNAH HATFIELD (?1754–?1827)
Daughter of Thomas Hatfield (below)

Oil on canvas
76·5 × 63·9 (30⅛ × 25 3/16)
Unsigned
J. B. Willans bequest (1957.408)

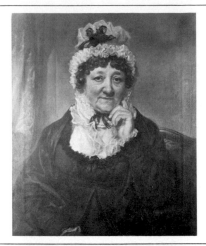

THOMAS HATFIELD (1725–1809)
Salford corn merchant

Oil on canvas
76·3 × 63·8 (30 1/16 × 25⅛)
Unsigned
J. B. Willans bequest (1957.409)

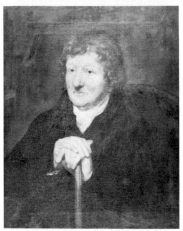

JOHN POOLEY (1801–1883)
Manchester cotton spinner
?1822

Oil on canvas
76 × 63 (29 15/16 × 24 13/16)
Unsigned
Mrs M. Ormsby gift (1926.170)

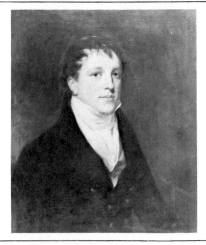

Sir Lawrence Alma–Tadema
1836–1912

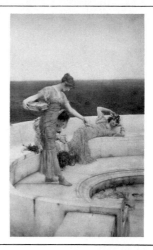

SILVER FAVOURITES
exh. 1903

Oil on panel
69·1 × 42·2 ($27\frac{3}{16} \times 16\frac{5}{8}$)
s(br): *L. Alma Tadema Op.*
CCCLXXIII
James Blair bequest (1917.235)

A ROMAN FLOWER MARKET
1868

Oil on panel
42 × 58 ($16\frac{1}{2} \times 22\frac{13}{16}$)
s(centre, under notice): *L ALMA*
TADEMA 1868
John E. Yates bequest (1934.417)

Richard Ansdell
1815–1885

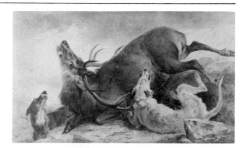

THE CHASE
(formerly called THE DEATH OF THE
STAG)
1847

Oil on canvas
166·5 × 290·5 ($65\frac{9}{16} \times 114\frac{3}{8}$)
s(brc): *Rich^d. Ansdell/1847*
Transferred from the Royal
Manchester Institution (1882.6)

TRAVELLER ATTACKED BY WOLVES
exh. 1854

*Painting awaiting restoration;
no photograph available*

Oil on canvas
274×377 ($107\frac{7}{8} \times 148\frac{7}{16}$)
Unsigned
L. L. Armitage gift (1912.49)

Richard Ansdell
See also Thomas Creswick

Henry Mark Anthony
1817–1886

THE VILLAGE CHURCH
1842

Oil on canvas
$50 \cdot 9 \times 76 \cdot 1$ ($20\frac{1}{16} \times 29\frac{15}{16}$)
s(blc): *MA/1842*
Purchased (1904.12)

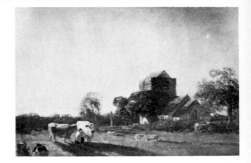

James Archer
1824–1904

THOMAS DE QUINCEY (1785–1859)
Writer
1903

Oil on canvas
$102 \cdot 7 \times 86 \cdot 5$ ($40\frac{7}{16} \times 34\frac{1}{16}$)
s(brc): *JA/1903* (mon)
Purchased (1904.3)

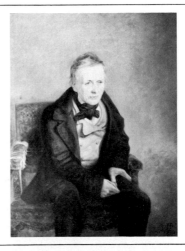

LA MORT D'ARTHUR
1860

Oil on millboard
43·2 × 50·9 (17 × 20)
s(bl on cloak): *18 JA 60* (mon)
Miss L. A. Haworth gift in memory of
Lady Haworth (1952.252)

Sir Martin Archer Shee
See Shee

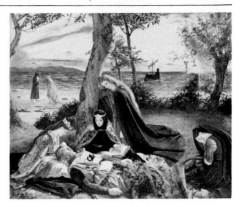

James Aumonier
1832–1911

THE SILVER LINING OF THE CLOUD
exh. 1890

Oil on canvas
105·4 × 181·3 (41½ × 71⅜)
s(brc): *J. Aumonier*
Frederick Smallman gift (1890.61)

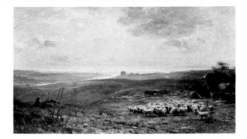

WHEN THE TIDE IS OUT
exh. 1895

Oil on canvas
108 × 154·2 (42½ × 60¾)
s(blc): *J. Aumonier*
Purchased (1895.3)

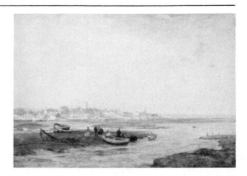

LANDSCAPE WITH SHEEP

Oil on canvas
$57 \cdot 3 \times 44 \cdot 7$ ($22\frac{9}{16} \times 17\frac{5}{8}$)
s(blc): *J. Aumonier*
Dr Jane Walker bequest (1939.21)

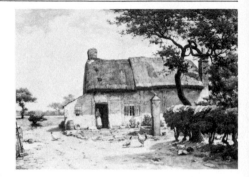

Elias Mollineaux Bancroft
1846–1924

MID-DAY CHESHIRE
?1884

Oil on canvas
$77 \cdot 4 \times 56$ ($30\frac{1}{2} \times 22\frac{1}{16}$)
s(brc): *ELIAS BANCROFT*.
Inscr (blc): *CHESHIRE*.
Gift of the Manchester Academy of
Fine Arts, to commemorate the
artist's services (1921.1)

John Joseph Barker of Bath
active 1835–1863

LANDSCAPE WITH MAN AND DONKEY

Oil on canvas, circular
$63 \cdot 1 \times 63 \cdot 1$ ($24\frac{13}{16} \times 24\frac{13}{16}$)
s(bl): *John J. Barker*
Gift of the executors of C. R.
Dunkerley (1951.393)

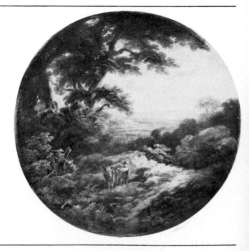

Thomas Barker of Bath

1769–1847
(formerly attributed to George
Lambert and Artist Unknown)

LANDSCAPE WITH CATTLE

Oil on canvas
$48\cdot5 \times 66\cdot1$ ($19\frac{1}{8} \times 26$)
Unsigned
Norman Spencer gift (1906.1)

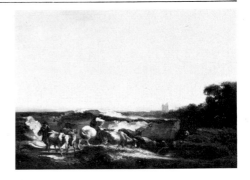

DISTANT VIEW OF MALVERN
1837

Oil on canvas
$63\cdot3 \times 75\cdot7$ ($24\frac{15}{16} \times 29\frac{13}{16}$)
s(brc): *T. Barker/Setr./1837* (mon)
Purchased (1963.352)

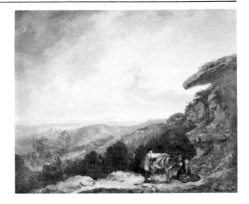

Frederick Barnard

1846–1896

A DRESS REHEARSAL
1868

Oil on panel
$76\cdot1 \times 86\cdot3$ (30×34)
s(blc): *Fred Barnard/68* (in one line)
Mrs C. S. Garnett bequest (1936.117)

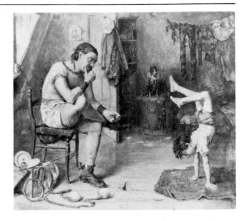

George Barret, Junior
1767–1842

THE SKETCHER

Oil on panel
$31 \times 40 \cdot 1$ ($12\frac{3}{16} \times 15\frac{3}{4}$)
Unsigned
Lloyd Roberts bequest (1920.542)

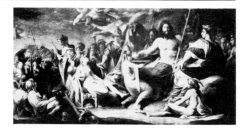

James Barry
1741–1806

THE BIRTH OF PANDORA
(also called PANDORA OR THE
HEATHEN EVE)

Oil on canvas
279×520 (110×205)
Unsigned
Transferred from the Royal
Manchester Institution (1882.12)

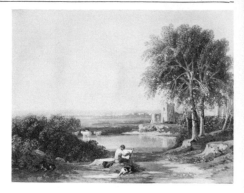

Thomas Beach
1738–1806

A LADY AS DIANA

Oil on canvas
$77 \times 64 \cdot 3$ ($30\frac{5}{16} \times 25\frac{5}{16}$)
Unsigned
Purchased (1949.255)

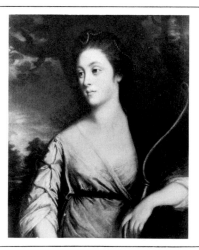

Charles Bentley
1806–1854

MONT ST MICHEL
1854

Oil on canvas
104·3 × 149·5 (41$\frac{1}{16}$ × 58$\frac{7}{8}$)
s(blc): *Chas. Bentley/1854*
Mrs C. J. Pooley gift (1927.25)

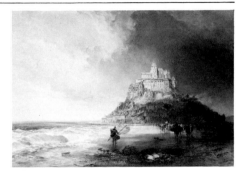

William Blake
1757–1827

WILLIAM SHAKESPEARE (1564–1616)
Dramatist and poet
c.1800

Tempera on canvas
41 × 79·5 (16$\frac{1}{8}$ × 31$\frac{5}{16}$)
Unsigned
Purchased (1885.2)

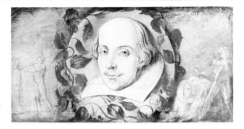

JOHN MILTON (1608–1674)
Poet
c.1800

Tempera on canvas
40·1 × 90·9 (15$\frac{3}{4}$ × 35$\frac{3}{4}$)
Unsigned
Purchased (1885.3)

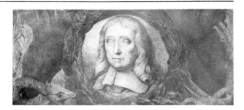

GEOFFREY CHAUCER (1344–?1400)
Poet
c.1800

Tempera on canvas
$42 \cdot 5 \times 63 \cdot 7$ ($16\frac{3}{4} \times 25\frac{1}{8}$)
Unsigned
Purchased (1885.4)

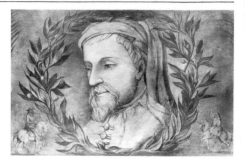

EDMUND SPENSER (*c*.1552–1599)
Poet
c.1800

Tempera on canvas
42×84 ($16\frac{1}{2} \times 33\frac{1}{16}$)
Unsigned
Purchased (1885.5)

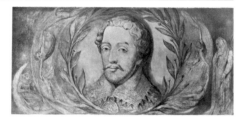

JOHN DRYDEN (1631–1700)
Poet
c.1800

Tempera on canvas
$40 \cdot 3 \times 80 \cdot 8$ ($15\frac{7}{8} \times 31\frac{13}{16}$)
Unsigned
Purchased (1885.6)

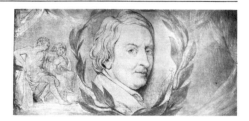

THOMAS OTWAY (1652–1685)
Dramatist
c.1800

Tempera on canvas
40·5 × 76·2 (15 $\frac{13}{16}$ × 30)
Unsigned
Purchased (1885.7)

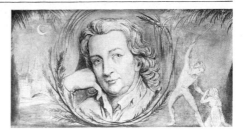

ALEXANDER POPE (1688–1744)
Poet
c.1800

Tempera on canvas
40·2 × 79·4 (15 $\frac{13}{16}$ × 31 $\frac{1}{4}$)
Unsigned
Purchased (1885.8)

WILLIAM COWPER (1731–1800)
Poet
c.1800

Tempera on canvas
41·9 × 83·6 (16 $\frac{1}{2}$ × 32 $\frac{7}{8}$)
Unsigned
Purchased (1885.9)

FRIEDRICH GOTTLIEB KLOPSTOCK
(1724–1803)
German poet
(formerly called BLAIR and YOUNG)
*c.*1800

Tempera on canvas
$43 \times 79 \cdot 8$ ($16\frac{15}{16} \times 31\frac{7}{16}$)
Unsigned
Purchased (1885.10)

THOMAS ALPHONSO HAYLEY (1781–
1800)
Sculptor
*c.*1800

Tempera on canvas
$41 \times 50 \cdot 3$ ($16\frac{1}{8} \times 19\frac{13}{16}$)
Unsigned
Purchased (1885.11)

ALONSO DE ERCILLA Y ZUNIGA (1533–
1594)
Spanish poet
*c.*1800

Tempera on canvas
$41 \cdot 8 \times 51 \cdot 7$ ($16\frac{7}{16} \times 20\frac{3}{8}$)
Unsigned
Purchased (1885.12)

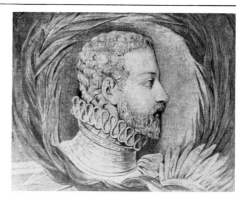

FRANÇOIS MARIE AROUET DE
VOLTAIRE (1694–1778)
French writer and philosopher
*c.*1800

Tempera on canvas
41·9 × 70·6 (16½ × 27 13/16)
Unsigned
Purchased (1885.13)

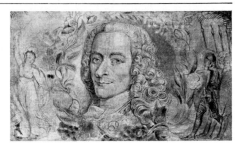

LOUIS VAZ DE CAMÕENS (?1524–1580)
Portuguese poet
*c.*1800

Tempera on canvas
41·5 × 56·5 (16 5/16 × 22¼)
Unsigned
Purchased (1885.14)

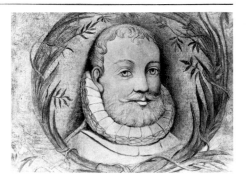

TORQUATO TASSO (1544–1595)
Italian poet
*c.*1800

Tempera on canvas
41·2 × 83·1 (16 3/16 × 32 11/16)
Unsigned
Purchased (1885.15)

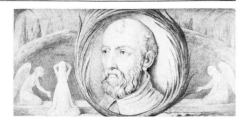

DANTE ALIGHIERI (1265–1321)
Italian poet
*c.*1800

Tempera on canvas
$42 \cdot 5 \times 87 \cdot 8$ ($16\frac{3}{4} \times 34\frac{9}{16}$)
Unsigned
Purchased (1885.16)

DEMOSTHENES (*c.*383–322 B.C.)
Greek orator
(formerly called EURIPIDES)
*c.*1800

Tempera on canvas
$42 \times 105 \cdot 9$ ($16\frac{1}{2} \times 41\frac{11}{16}$)
Unsigned
Purchased (1885.17)

MARCUS TULLIUS CICERO (106–43
B.C.)
Roman orator
(formerly called LUCAN)
*c.*1800

Tempera on canvas
$41 \cdot 5 \times 103$ ($16\frac{5}{16} \times 40\frac{9}{16}$)
Unsigned
Purchased (1885.18)

HOMER (*c*.950 B.C.)
Greek epic poet
c.1800

Tempera on canvas
40×84 ($15\frac{3}{4} \times 33\frac{1}{16}$)
Unsigned
Purchased (1885.19)

Alfred Bottomley
active 1859–63

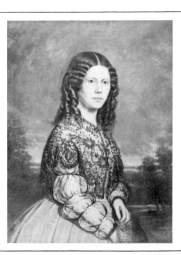

HENRIETTA DEPLIDGE
Wife of the artist
?1859

Oil on canvas
$91 \cdot 7 \times 71 \cdot 3$ ($36\frac{1}{8} \times 28\frac{1}{16}$)
Unsigned
Mrs F. M.Clarke and Mrs D.
Williamson gift (1972.206)

Attributed to Alfred Bottomley

SELF-PORTRAIT

Oil on canvas
$15 \times 12 \cdot 7$ ($5\frac{7}{8} \times 5$)
Unsigned
Mrs F. M. Clarke and Mrs
D. Williamson gift (1972.207)

A LITTLE GIRL

Oil on millboard
34·6 × 28 (13⅝ × 11)
Unsigned
Mrs F. M. Clarke and Mrs
D. Williamson gift (1972.208)

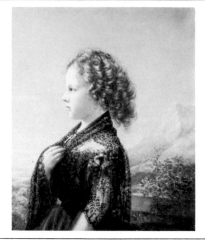

A LITTLE BOY
Said to be Alfred Bottomley, Junior

Oil on millboard
35·1 × 29·7 (13 13/16 × 11 11/16)
Unsigned
Mrs F. M. Clarke and Mrs
D. Williamson gift (1972.209)

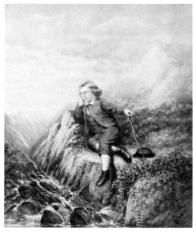

Samuel Bough
1822–1878

A CASTLE
1857

Oil on canvas
55·3 × 85·4 (21¾ × 33⅝)
s(blc): *Sam Bough 1857*/(?) *Wye
Castle*
Purchased (1902.13)

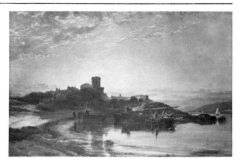

EDINBURGH FROM LEITH ROADS
1854

Oil on canvas
101·9 × 127·5 (40⅛ × 50 3/16)
s(blc): *Edinburgh / from Leith Roads /
Sam Bough 1854.*
Jesse Haworth bequest (1937.125)

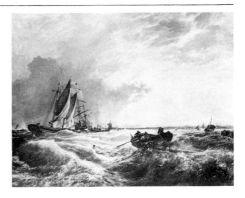

After Edward Bower
active 1635–1667
(formerly attributed to Henry Stone)

THOMAS FAIRFAX, 3RD BARON
FAIRFAX (1612–1671)
(formerly called EDMUND, FIRST
MARQUIS OF NORMANBY)

Oil on canvas
76·8 × 63·2 (30¼ × 24⅞)
Unsigned
Purchased (1903.13)

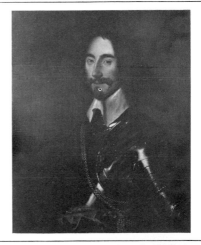

John Boydell
1839–1913

THE LLEDR VALLEY NEAR BETTWYS-
Y-COED
1877

Oil on canvas
102·5 × 153·3 (40⅜ × 60⅜)
s(bl): *J. BOYDELL / 1877*
Mrs F. G. Whitehead gift (1910.40)

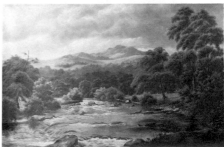

Basil Bradley
1842–1904

A RED SQUIRREL EATING A NUT

Oil on millboard
30·5 × 22·8 (12 × 9)
s(blc): *B Bradley* (mon)
Transferred from the Horsfall Museum
(1918.434)

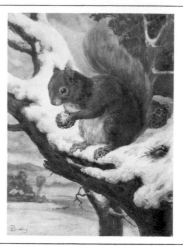

William Bradley
1801–1857

CHARLES SWAIN (1803–1874)
Manchester poet
?exh. 1837

Oil on canvas
76·3 × 64·3 (30 × 25 $\frac{5}{16}$)
Unsigned
Mrs C. Swain Dickins gift (1888.7)

SIR BENJAMIN HEYWOOD, BT. (1793–1865)
Banker, M.P., first President of the
Manchester Mechanics' Institution
1824, and Vice-President of the Royal
Manchester Institution
exh. 1844

Oil on canvas
251 × 159·5 (98 $\frac{13}{16}$ × 62 $\frac{13}{16}$)
Unsigned
Manchester Education Committee
gift (1903·17)

GEORGE FRASER
First Captain of the Manchester Golf
Club (1818)

Oil on canvas
111·8 × 91·5 (44 × 36)
Unsigned
Gift of the shareholders of George
Fraser, Sons & Co. Ltd (1930.150)

THE ENGLISH BELLE

Oil on canvas
77 × 63·7 (30 $\frac{5}{16}$ × 25 $\frac{1}{16}$)
Unsigned
Mrs C. S. Garnett bequest (1936.118)

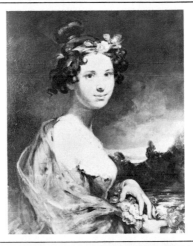

Attributed to William Bradley

A LADY IN A PLUMED HAT
c.1830

Oil on canvas
56·1 × 45·8 (22 $\frac{1}{16}$ × 18)
Unsigned
Lloyd Roberts bequest (1920.553)

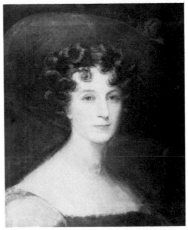

John Brett
1830–1902

THE NORMAN ARCHIPELAGO
(in the Channel Islands)
1885

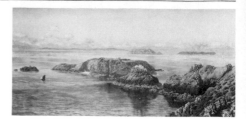

Oil on canvas
107·2 × 214 (42 $\frac{3}{16}$ × 84 $\frac{1}{4}$)
s(blc): *John Brett 1885*
Purchased (1885.25)

SEASCAPE
1881

Oil on canvas
17·8 × 35·6 (7 × 14)
Unsigned. Inscr (tlc): (?) *Trevose Head.*
June 7.81
Tranferred from the Horsfall Museum
(1918.414)

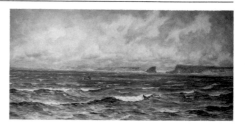

Attributed to Henry Bright
1814–1873

ON THE RIVER BANK

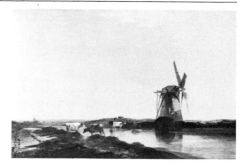

Oil on panel
35 × 52·4 (13 $\frac{3}{4}$ × 20 $\frac{5}{8}$)
Unsigned
Purchased (1905.28)

William Bromley

active 1835–1888

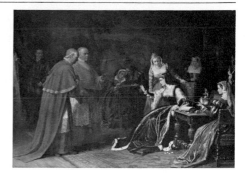

CATHERINE OF ARAGON
1866

Oil on canvas
$107 \cdot 5 \times 153 \cdot 3$ $(42\frac{5}{16} \times 60\frac{3}{8})$
s(brc): *W Bromley. 1866*
Miss H. L. Maw bequest (1910.18)

Richard Brompton

1734–1783

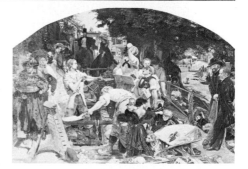

JOHN HORNE TOOKE (1736–1812)
Radical politician and philologist

Oil on canvas
$126 \cdot 5 \times 102 \cdot 7$ $(49\frac{13}{16} \times 40\frac{7}{16})$
Unsigned
Purchased (1913.16)

Ford Madox Brown

1821–1893

WORK
1852–1865

Oil on canvas, arched top
$137 \times 197 \cdot 3$ $(53\frac{15}{16} \times 77\frac{11}{16})$
s(brc): *F. MADOX BROWN
1852–/65* (in one line)
Purchased (1885.1)

WILLIAM SHAKESPEARE (1564–1616)
Dramatist and poet
1849

Oil on canvas
135·6 × 87·5 ($53\frac{3}{8} \times 34\frac{7}{16}$)
Unsigned
Purchased (1900.16)

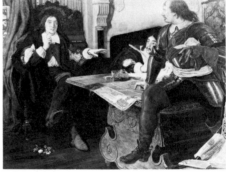

CROMWELL, PROTECTOR OF THE
VAUDOIS
1877

Oil on canvas
86 × 107 ($33\frac{7}{8} \times 42\frac{1}{8}$)
s(blc): *FMB – 77* (mon)
Lieut-Col. H. J. Candlin gift (1901.12)

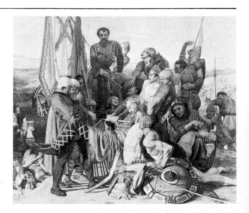

THE BODY OF HAROLD BROUGHT
BEFORE WILLIAM THE CONQUEROR
(WILHELMUS CONQUISTATOR)
1844–61

Oil on canvas
105 × 123·1 ($42\frac{5}{16} \times 48\frac{7}{16}$)
s(blc): *F. MADOX BROWN 1844–61*
Purchased (1907.9)

STAGES OF CRUELTY
1856–90

Oil on canvas
73·3 × 59·9 (28⅞ × 23 9/16)
s(blc) : *FMB – 56/ – 90* (mon)
Purchased (1911.105)

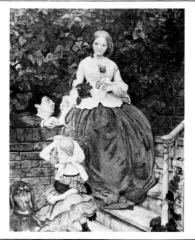

THE PRISONER OF CHILLON
(from Byron's poem)
1843

Oil on canvas
53·2 × 64·9 (20 15/16 × 25 9/16)
Unsigned
Harold Rathbone gift (1911.107)

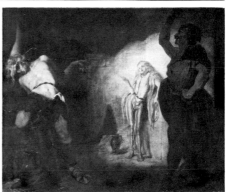

DR. PRIMROSE AND HIS DAUGHTERS
(from 'The Vicar of Wakefield')

Oil on canvas
72·6 × 58·7 (28 9/16 × 23⅛)
Unsigned
Purchased (1912.61)

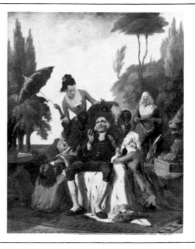

REV. F. H. S. PENDLETON (1818–1888)
1837

Oil on panel
$16 \cdot 9 \times 13 \cdot 3$ ($6\frac{5}{8} \times 5\frac{1}{4}$)
s(brc): *F.M. BROWN | à son ami | . . .*
(illegible)
Purchased (1913.10)

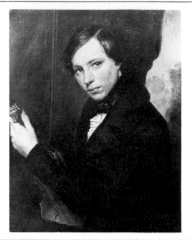

MANFRED ON THE JUNGFRAU
(from Byron's 'Manfred', I, 3)
1840–61

Oil on canvas
$140 \cdot 2 \times 115$ ($55\frac{3}{16} \times 45\frac{1}{4}$)
s(brc): *Ford Madox Brown*
F. W. Jackson gift (1916.13)

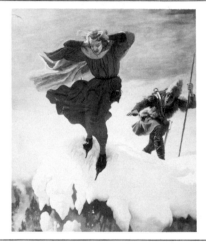

HEATH STREET, HAMPSTEAD
(Study for WORK)
1852–55

Oil on canvas, with pencil, arched top
$22 \cdot 8 \times 30 \cdot 8$ ($9 \times 12\frac{1}{8}$)
Unsigned
Purchased (1924.30)

THE TRAVELLER
1868–84

Oil on panel
31·6 × 48·6 (12$\frac{7}{16}$ × 19$\frac{1}{8}$)
s(brc) : $FMB – 84$ (mon)
Purchased (1925.83)

IRON
WEAVING
SHIPPING
SPINNING
COMMERCE
CORN
WOOL
(Decorations for the Royal Jubilee
Exhibition, Manchester 1887)

All oil on canvas
400 × 400 (157$\frac{1}{2}$ × 157$\frac{1}{2}$) approx.
(irregular)
Unsigned
Edgar Wood gift (1926.77–83)

*Painting awaiting restoration;
no photograph available*

STUDY OF A COURTIER FOR 'CHAUCER
AT THE COURT OF EDWARD III'
1848

Oil on millboard
60·9 × 46·6 (24 × 18$\frac{5}{16}$)
Unsigned
Sir Michael E. Sadler gift, in memory
of Lady Sadler, through the
N.A-C.F. (1931.21)

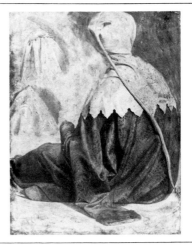

THE ENGLISH BOY
Oliver Madox Brown (1855–74)
1860

Oil on canvas
$39 \cdot 6 \times 33 \cdot 3$ ($15\frac{9}{16} \times 13\frac{1}{8}$)
s(trc): *F. MADOX BROWN | 60* (in
one line)
C. P. Scott bequest (1932.10)

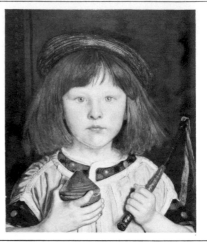

MADELINE SCOTT (1876–1958)
Daughter of C. P. Scott;
m. 1898 C. E. Montague
1883

Oil on canvas
$122 \cdot 1 \times 78 \cdot 5$ ($48\frac{1}{16} \times 30\frac{7}{8}$)
s(brc): *FMB – 83* (mon)
C. P. Scott bequest (1932.14)

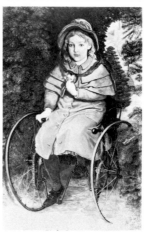

TWO STUDIES OF A LITTLE GIRL'S
HEAD
Millie Smith (formerly called TWO
CHILDREN)
1847

Oil on linen
$35 \cdot 6 \times 45 \cdot 8$ (14×18)
s(brc): *F. Madox Brown. 1847.*
G. Beatson Blair bequest 1941
(1947.70)

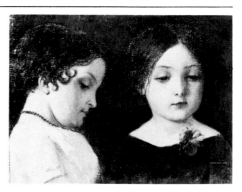

UNFINISHED SKETCH FOR 'JOHN KAY,
INVENTOR OF THE FLY SHUTTLE'
(Mural painting at Manchester Town
Hall)
1888

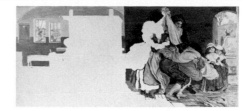

Tempera on panel
$35\cdot4 \times 78\cdot8$ ($13\frac{15}{16} \times 31$)
Unsigned
G. Beatson Blair bequest 1941
(1947.81)

BYRON'S DREAM
1874

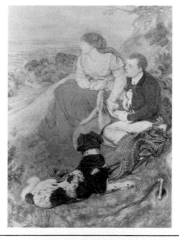

Oil on canvas
$71\cdot5 \times 54\cdot8$ ($28\frac{1}{8} \times 21\frac{9}{16}$)
s(brc): $FMB - 74$ (mon)
G. Beatson Blair bequest 1941
(1947.82)

THE PROCLAMATION REGARDING
WEIGHTS AND MEASURES
(Reduced version of mural painting at
Manchester Town Hall)
1889

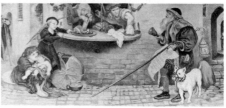

Tempera on panel
$26\cdot2 \times 56\cdot9$ ($10\frac{5}{16} \times 22\frac{3}{8}$)
s(blc): $FMB\ Nov - 89$ (mon)
G. Beatson Blair bequest 1941
(1947.85)

THE ESTABLISHMENT OF THE FLEMISH
WEAVERS IN MANCHESTER
(Reduced version of mural painting at
Manchester Town Hall)
1888

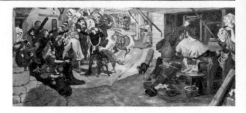

Tempera on panel
$27 \cdot 1 \times 55 \cdot 9 \ (10\frac{5}{8} \times 22)$
s(blc): $FMB - 88$ (mon)
G. Beatson Blair bequest 1941
(1947.86)

CRABTREE WATCHING THE TRANSIT OF
VENUS
(Reduced version of mural painting at
Manchester Town Hall)
1881–8

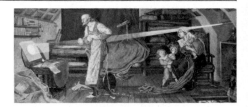

Tempera on panel
$26 \cdot 4 \times 55 \cdot 9 \ (10\frac{3}{8} \times 22)$
s(brc): $FMB - 81 - 88$ (mon)
G. Beatson Blair bequest 1941
(1947.87)

OUT OF TOWN
1858

Oil on canvas
$23 \cdot 2 \times 14 \cdot 4 \ (9\frac{1}{8} \times 5\frac{11}{16})$
s(on bench, r): $FMB - 58$ (mon)
G. Beatson Blair bequest 1941
(1947.94)

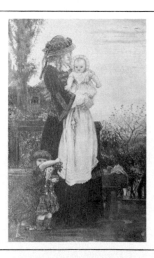

FAMILY GROUP
The Bromley family
1844

Oil on canvas
$117 \cdot 4 \times 81 \cdot 1$ $(46\frac{3}{16} \times 31\frac{15}{16})$
s(brc): *F.M. BROWN / 1844*
G. Beatson Blair bequest 1941
(1947.142)

Henriette Browne
See Foreign Schools catalogue

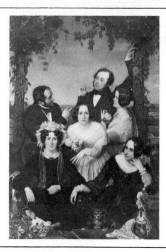

Sir Edward Coley Burne–Jones
1833–1898

SIBYLLA DELPHICA
exh. 1886

Oil on panel
$152 \cdot 8 \times 60 \cdot 3$ $(60\frac{1}{8} \times 23\frac{3}{4})$
s(br on pier): *E.B.J.* (mon)
Purchased (1886.5)

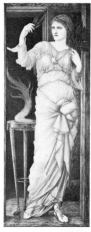

John Burr
1831/4–1893

THE INCORRIGIBLE
1879

Oil on canvas
$91 \cdot 3 \times 71 \cdot 2$ $(35\frac{15}{16} \times 28\frac{1}{16})$
s(blc): *John Burr / 1879*
Miss H. L. Maw bequest (1910.19)

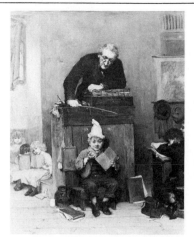

Lady Elizabeth Southerden Butler
(née **Thompson**)
1846–1933

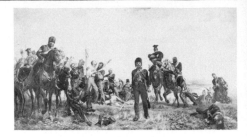

BALACLAVA
1876

Oil on canvas
$103 \cdot 4 \times 187 \cdot 5$ $(40\frac{15}{16} \times 73\frac{13}{16})$
s(blc): *18 ET 76* (mon) / *E.T.*
Robert Whitehead gift in memory of
John Whitehead (1898.13)

Randolph Caldecott
1846–1886

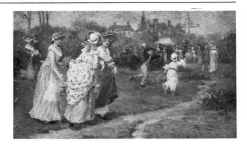

MAY DAY
exh. 1884

Oil on millboard
$14 \cdot 1 \times 22 \cdot 9$ $(5\frac{9}{16} \times 9)$
s(blc): *R C*
Purchased (1884.12)

THE GIRL I LEFT BEHIND ME
exh. 1886

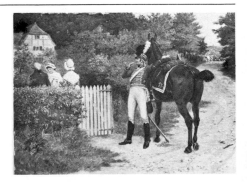

Oil on panel
$20 \cdot 9 \times 30 \cdot 3$ $(8\frac{1}{4} \times 11\frac{15}{16})$
s(brc): *R C*
Purchased (1886.3)

Philip Hermogenes Calderon
1833–1898

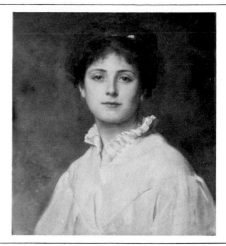

MARGARET
exh. 1876

Oil on canvas
$51 \cdot 1 \times 46 \cdot 3$ ($20\frac{1}{8} \times 18\frac{1}{4}$)
Unsigned. Inscr (verso): *P.H.*
CALDERON/No 4/"MARGARET"
James Blair bequest (1917.214)

Sir Augustus Wall Callcott
1779–1844

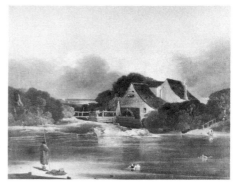

LANDSCAPE WITH WATER MILL

Oil on canvas
71×91 ($27\frac{15}{16} \times 35\frac{13}{16}$)
Unsigned
Purchased (1898.6)

VIEW OF GHENT

Oil on canvas
$74 \times 104 \cdot 5$ ($29\frac{1}{8} \times 41\frac{1}{8}$)
Unsigned
Mrs J. Worthington bequest (1905.3)

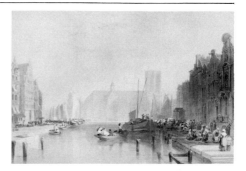

George D. Callow
active 1858–1876

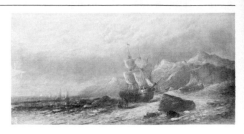

ROCKY COAST WITH SAILING SHIPS

Oil on canvas
$20 \times 40 \cdot 1$ $(7\frac{7}{8} \times 15\frac{13}{16})$
s(bl): *G D Callow*
F. E. Simpson gift (1966.627)

COASTAL SCENE WITH SAILING SHIPS
?1876

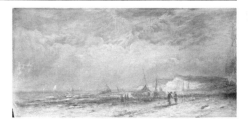

Oil on canvas
20×40 $(7\frac{7}{8} \times 15\frac{3}{4})$
s(bl): *G D Callow 76*(?)
F. E. Simpson gift (1966.628)

William Callow
1812–1908

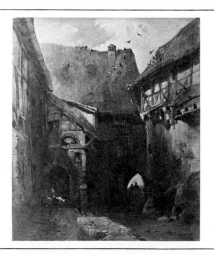

THE WARTBURG; THE PLACE OF
LUTHER'S CAPTIVITY IN 1521
1855

Oil on panel
$35 \cdot 5 \times 30 \cdot 1$ $(14 \times 11\frac{7}{8})$
s twice, (b l of centre) and (brc):
W. Callow/1855
Purchased (1903.12)

James Wilson Carmichael
c.1800–1868

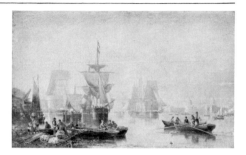

SHIPPING ON THE THAMES
1863

Oil on canvas
61·8 × 99·5 (24$\frac{5}{16}$ × 39$\frac{3}{16}$)
s(blc): *J W Carmichael / 1863*
Transferred from the Horsfall
Museum (1918.413)

George Chambers, Junior
active 1848–1862

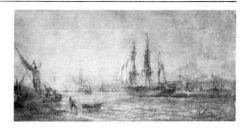

SHIPS OFF THE COAST
?1870

Oil on canvas
20·2 × 40·3 (7$\frac{15}{16}$ × 15$\frac{7}{8}$)
s(blc): *G Chambers / 70* (?)
F. E. Simpson gift (1966.625)

George Cole
1808–1883

SHOWERY WEATHER
1877

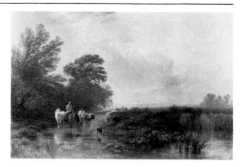

Oil on canvas
50·8 × 76·5 (22$\frac{13}{16}$ × 30$\frac{1}{8}$)
s(blc): *G. Cole. / 1877*
James Blair bequest (1917.184)

George Vicat Cole
1833–1893

THE HEART OF SURREY
1874

Oil on canvas
142·2 × 214·5 (56 × 84$\frac{7}{16}$)
s(blc): *18 VC 74* (mon); s(brc):
VICAT COLE 1874
Purchased (1895.1)

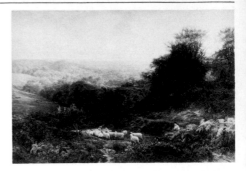

SPRINGTIME
1865

Oil on canvas
66·1 × 101·7 (26 × 40$\frac{1}{16}$)
s(blc): *Vicat Cole 1865*
James Blair bequest (1917.232)

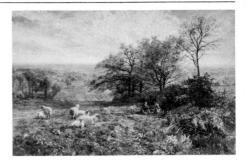

Samuel David Colkett
1800/6–1863

FARMHOUSE WITH POND

Oil on panel
25·5 × 34·6 (10 × 13$\frac{5}{8}$)
Unsigned
Gift of the Executors of J. R. Oliver
(1934.437)

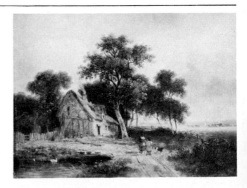

Charles Allston Collins
1828–1873

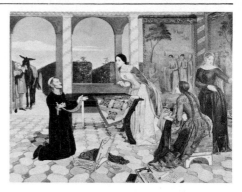

BERENGARIA'S ALARM FOR THE
SAFETY OF HER HUSBAND, RICHARD
COEUR DE LION, AWAKENED BY THE
SIGHT OF HIS GIRDLE OFFERED FOR
SALE AT ROME (also called THE PEDLAR)
1850

Oil on canvas
101·2 × 106·7 (39⅞ × 42)
s(br): *CHARLES COLLINS 1850*
Purchased (1896.1)

William Collins
1788–1847

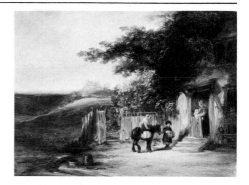

THE COTTAGE DOOR
1825

Oil on panel
25·4 × 33·1 (10 × 13)
s(br): *WC 1825*
John E. Yates bequest (1934.392)

James Collinson
1825–1881

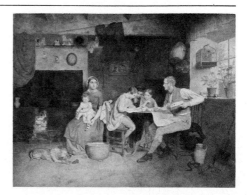

ANSWERING THE EMIGRANT'S LETTER
1850

Oil on panel
70·1 × 91·2 (27⅝ × 35⅞)
s(brc): *J. Collinson. 1850.*
Purchased (1966.179)

Edward Thomas Compton
1849–1921

THE JUNGFRAU
1890

Oil on canvas
125·8 × 180·3 (49½ × 71)
s(blc): *E. T. COMPTON | 1890 | DCXCV*
Gift of the Trustees of Samuel
Redfern (1927.57)

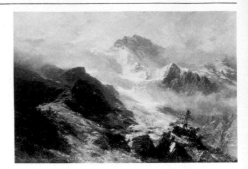

John Constable
1776–1837

COTTAGE IN A CORNFIELD
?*c*.1815–16

Oil on canvas
30·3 × 35·2 ($11\frac{15}{16}$ × $13\frac{7}{8}$)
Unsigned
James Blair bequest (1917.171)

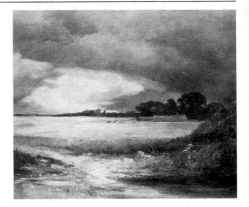

HAMPSTEAD
(looking towards Harrow, with
Branch Hill Pond in the foreground)
1821

Oil on paper on canvas
25 × 29·8 ($9\frac{7}{8}$ × $11\frac{3}{4}$)
Inscr (label pasted on stretcher):
*August 1821 | 5 Oclock afternoon : very
fine | bright & wind after rain
slightly | in the morning.*
James Blair bequest (1917.176)

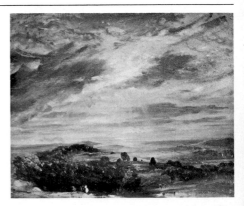

Attributed to John Constable
1776–1837

MOONLIGHT AT BRIGHTON
?c.1824–5

Oil on paper on panel
$25 \times 30 \cdot 1$ ($9\frac{13}{16} \times 11\frac{7}{8}$)
Unsigned
Purchased (1909.12)

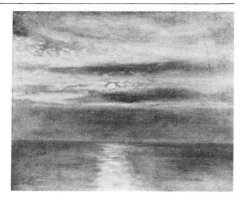

EARLY MORNING
c.1809

Oil on paper on panel
$23 \cdot 8 \times 30 \cdot 1$ ($9\frac{3}{8} \times 11\frac{15}{16}$)
Unsigned
Purchased (1909.13)

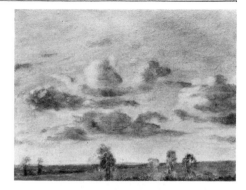

Follower of John Constable

SOUTH DOWNS

Oil on millboard
$25 \cdot 7 \times 34 \cdot 3$ ($10\frac{1}{8} \times 13\frac{1}{2}$)
Unsigned
Sir Michael Sadler gift, in memory of
Lady Sadler, through the N.A-C.F.
(1931.22)

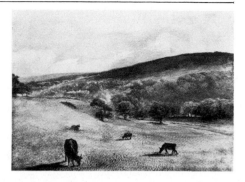

A WINDY DAY

Oil on paper on panel
$15 \cdot 3 \times 23 \cdot 4$ $(6 \times 9\frac{3}{16})$
Unsigned
G. Beatson Blair bequest 1941
(1947.68)

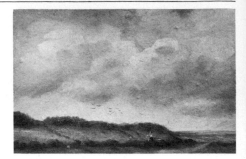

LANDSCAPE WITH A FISHERMAN ON A BRIDGE

Oil on canvas
$30 \cdot 4 \times 40 \cdot 8$ $(12 \times 16\frac{1}{16})$
Unsigned
James Gresham bequest (1917.253)

John Constable
See also Peter de Wint

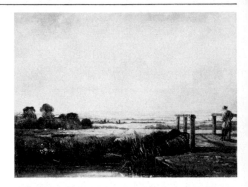

Edward William Cooke
1811–1880

ON THE SHORE AT SCHEVELING –
LOW WATER
1872

Oil on millboard
$23 \cdot 2 \times 31 \cdot 5$ $(9\frac{1}{8} \times 12\frac{3}{8})$
s(blc): *E W Cooke. RA. 1872.*
James Blair bequest (1917.202)

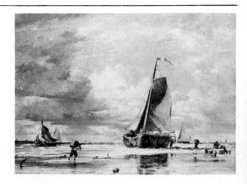

THE NILE
1862

Oil on paper on canvas
$19 \cdot 6 \times 28 \cdot 2$ $(7\frac{3}{4} \times 11\frac{1}{8})$
s(blc): *E W Cooke ARA. 1862.*
James Blair bequest (1917.206)

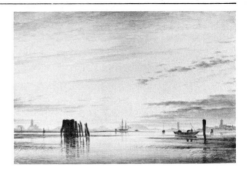

Thomas Sidney Cooper
1803–1902

CATTLE CROSSING A STREAM

Oil on canvas
$39 \cdot 9 \times 53 \cdot 7$ $(15\frac{11}{16} \times 21\frac{1}{8})$
Unsigned
Sir Joseph Whitworth bequest
(1896.9)

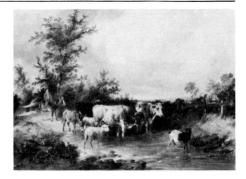

O'ER THE BRAES OF BALQUHIDDER
(Perthshire)
1896–7

Oil on canvas
$121 \cdot 9 \times 180 \cdot 3$ (48×71)
s(blc): *T.Sidney. Cooper. RA / 1896.97*
Mrs E. A. Rylands bequest (1908.16)

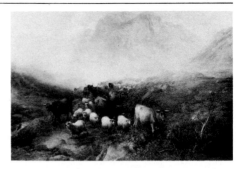

HEAT SHOWERS IN AUGUST
1857

Oil on panel
50×71 $(19\frac{11}{16} \times 27\frac{15}{16})$
s(br): *T Sidney Cooper ARA/1857*
Mrs I. C. Rayner gift (1921.16)

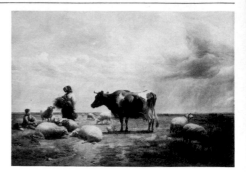

CATTLE BY THE RIVER SIDE
1871

Oil on panel
$45\cdot7 \times 60\cdot9$ $(17\frac{3}{4} \times 24)$
s(brc): *T Sidney. Cooper. | 1871*
John E. Yates bequest (1934.410)

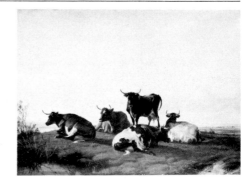

SHEEP ON THE COMMON
1873

Oil on panel
$45\cdot5 \times 61\cdot1$ $(17\frac{15}{16} \times 24\frac{1}{16})$
s(bl): *T. Sidney. Cooper. R.A./1873*
John E. Yates bequest (1934.411)

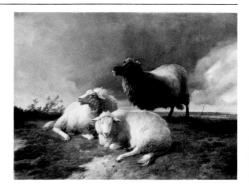

Thomas Sidney Cooper
1803–1902
and James Baker Pyne
1800–1870

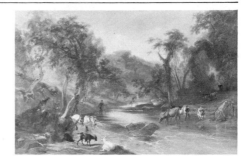

CATTLE CROSSING A STREAM AND A
MAN FISHING

Oil on canvas
85.5×131 ($33\frac{11}{16} \times 51\frac{9}{16}$)
Unsigned
Sir Joseph Whitworth bequest
(1896.14)

David Cox
1783–1859

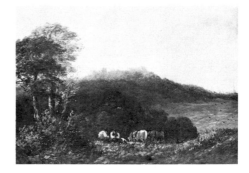

DUDLEY CASTLE
1853

Oil on canvas
30.1×41 ($11\frac{7}{8} \times 16\frac{1}{8}$)
s(blc): *David Cox. 1853.*
Purchased (1900.22)

THE GATHERING OF THE FLOCK
(also called COLLECTING THE FLOCKS
IN NORTH WALES)
1848

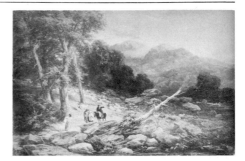

Oil on canvas
93.8×142 ($36\frac{15}{16} \times 55\frac{7}{8}$)
s(blc): *David Cox 1848*
Edward Behrens gift in memory of
his brother Frank (1902.10)

CROSSING THE FORD
(also called A PASS IN WALES:
CATTLE AT A FORD)
1849

Oil on canvas
35·8 × 45·7 ($14\frac{1}{8}$ × 18)
s(blc): *David Cox/1849*
James Blair bequest (1917.163)

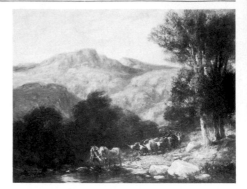

CROSSING THE MOOR
(also called ON THE MOORS)
1851

Oil on panel
30 × 40·5 ($11\frac{13}{16}$ × $15\frac{15}{16}$)
s(bl): *David Cox. 1851.*
James Blair bequest (1917.167)

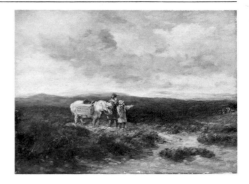

RHYL SANDS
c. 1854

Oil on canvas
45·8 × 63·5 (18 × 25)
Unsigned
James Blair bequest (1917.170)

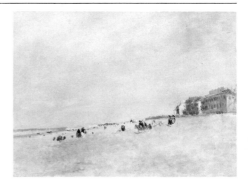

BOYS FISHING
1849

Oil on panel
22·4 × 35·7 (8 13/16 × 14 1/16)
s(blc): *David Cox/1849*
Jesse Haworth bequest (1937.127)

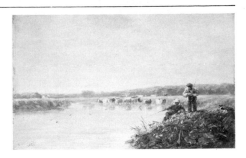

LANDSCAPE WITH MAN ON HORSE
1849

Oil on panel
16·1 × 31·7 (6 5/16 × 12 1/2)
s(blc): *D. Cox 1849.*
G. Beatson Blair bequest 1941
(1947.60)

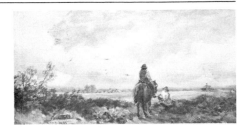

HAYMAKING NEAR CONWAY
1852–3

Oil on canvas
47·5 × 72·8 (18 11/16 × 28 11/16)
s(blc): *David Cox. 1852–3*
F. J. Nettlefold gift (1948.49)

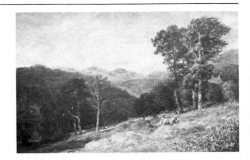

Thomas Creswick
1811–1869

THE RIVER TEES AT ROKEBY
(Yorkshire)
?exh. 1862

Oil on canvas
48·2 × 66·3 (19 × 26⅛)
s(brc): *T CRESWICK*
Purchased (1904.7)

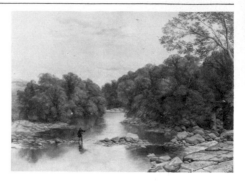

THE MOUTH OF A RIVER
?exh. 1855

Oil on panel
20·4 × 25·6 (8 × 10 1/16)
Unsigned
James Blair bequest (1917.160)

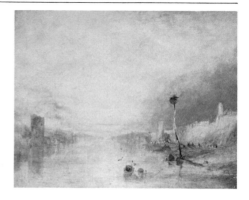

COAST SCENE WITH FIGURES

Oil on panel
17·8 × 28 (7 × 11)
Unsigned
Mrs Annie Woodhouse bequest
(1940.80)

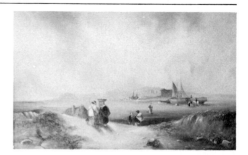

Thomas Creswick
1811–1869
and **Richard Ansdell**
1815–1885

THE WEALD, SURREY

Oil on canvas
101·2 × 127 ($39\frac{7}{8}$ × 50)
Unsigned
James Gresham bequest (1917.264)

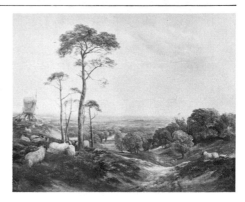

John Crome
1768–1821

VIEW NEAR NORWICH WITH
HARVESTERS

Oil on panel
39 × 53·8 ($15\frac{3}{8}$ × $21\frac{3}{16}$)
Unsigned
Purchased (1900.10)

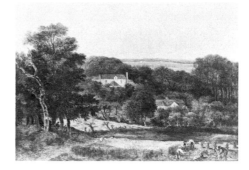

(formerly attributed to John Berney
Crome)

THE STEAM PACKET
(also called BOATS: JUNCTION OF THE
YARE AND WAVENEY)
c.1813–1817

Oil on panel
51·5 × 42·4 ($20\frac{1}{4}$ × $16\frac{11}{16}$)
Unsigned
Purchased (1905.5)

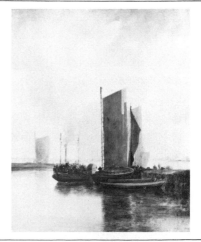

William Henry Crome
1806–1873

WOODED LANDSCAPE WITH COTTAGE

Oil on panel
$67 \cdot 3 \times 94 \cdot 6$ $(26\frac{1}{2} \times 37\frac{1}{4})$
Unsigned
Miss Lillie Pickles gift in memory of
her parents (1914.83)

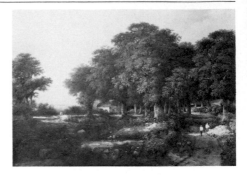

WOODED LANDSCAPE WITH WINDMILL
1843

Oil on panel
$67 \cdot 1 \times 94 \cdot 2$ $(26\frac{3}{8} \times 37\frac{1}{16})$
s(brc): *W H Crome/1843.*
Miss Lillie Pickles gift in memory of
her parents (1914.84)

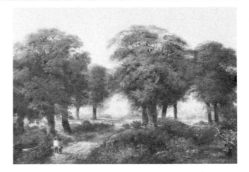

Eyre Crowe
1824–1910

THE DINNER HOUR, WIGAN
1874

Oil on canvas
$76 \cdot 3 \times 107$ $(30\frac{1}{16} \times 42\frac{1}{8})$
s(blc): *E. CROWE/1874*
Purchased (1922.48A)

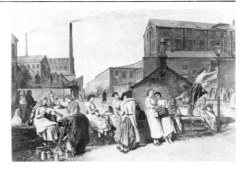

Robert Crozier
1815–1891

THE PATRIOT
John Sheldon
1846

Oil on canvas
91×71 ($35\frac{13}{16} \times 27\frac{15}{16}$)
Unsigned
Purchased (1909.20)

Susan Isabel Dacre
1844–1933

ITALIAN CHILD

Oil on panel
$32 \cdot 1 \times 23 \cdot 9$ ($12\frac{5}{8} \times 9\frac{3}{8}$)
Unsigned
Henry Boddington gift (1884.15)

ITALIAN GIRL WITH NECKLACE

Oil on canvas on panel
$38 \cdot 7 \times 27 \cdot 5$ ($15\frac{1}{4} \times 10\frac{13}{16}$)
Unsigned
Henry Boddington gift (1884.16)

ALDERMAN SIR THOMAS BAKER (1810–1886)
1886

Oil on canvas
63·9 × 49·1 (25⅛ × 19⁵⁄₁₆)
s(brc): *Sir Thomas sat for this sketch | a week before he died. | S. Isabel Dacre | 1886.*
inscr (t): *Sir Thomas Baker. Kᵗ Born 1810 Died 1886 Mayor of Manchester from 1882 to 1884.*
Henry Boddington gift (1911.26)

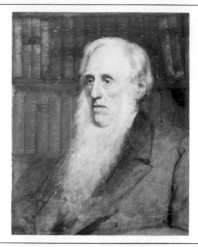

LITTLE ANNIE ROONEY
1898

Oil on canvas
71·4 × 53·6 (28⅛ × 21⅛)
s(blc): *S. Isabel Dacre/1898*
Gift of friends of the Gallery
(1911.30)

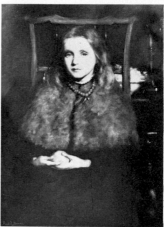

LYDIA BECKER (1827–1890)
Suffragette

Oil on canvas
66·5 × 52·3 (26³⁄₁₆ × 20⅝)
Unsigned
Gift of the National Union of Women's Suffrage, Manchester Branch (1920.1)

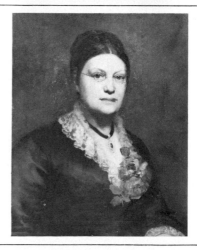

LOUISE
Louise Fichet
*c.*1879

Oil on canvas
35·6 × 25·6 (14 × 10)
s(brc): *S. Isabel Dacre*
Purchased (1923.6)

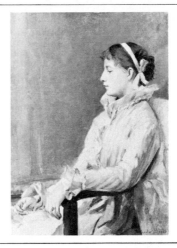

ITALIAN WOMEN IN CHURCH

Oil on canvas
76 × 61 (29$\frac{15}{16}$ × 24)
s(brc): *S. Isabel Dacre*
Gift of a group of subscribers (1927.14)

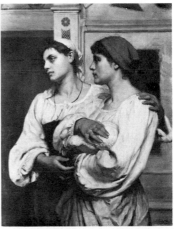

SWANS

Oil on canvas
30·5 × 40·5 (12 × 15$\frac{15}{16}$)
s(blc): *S Isabel Dacre*
Purchased (1927.55)

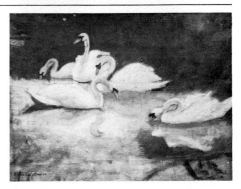

A VIEW IN VENICE
1880

Oil on canvas on panel
$34 \cdot 6 \times 27$ ($13\frac{5}{8} \times 10\frac{5}{8}$)
s(brc): *S. Isabel Dacre*
Thomas Gough gift (1928.5)

A GIRL
Bertha Edgar

Oil on panel
$50 \cdot 7 \times 33$ ($19\frac{15}{16} \times 13$)
Formerly inscr (tl): *BERTHA*.
and s(br): *S. Isab*(el Dacre)
Miss Bertha Edgar gift (1931.46)

ASSISI

Oil on canvas on panel
$43 \cdot 8 \times 58 \cdot 7$ ($17\frac{1}{4} \times 23\frac{1}{8}$)
s(brc): *S. Isabel Dacre*
C. P. Scott bequest (1932.12)

ASSISI FROM PERUGIA
*c.*1899

Oil on canvas
$30 \cdot 6 \times 38 \cdot 1$ ($12\frac{1}{16} \times 15$)
Unsigned
C. P. Scott bequest (1932.13)

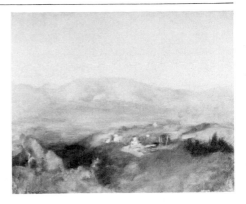

THE ARTIST'S MOTHER
*c.*1884

Oil on canvas
$91 \cdot 3 \times 73 \cdot 7$ ($35\frac{15}{16} \times 29\frac{1}{16}$)
s(trc): *Dear Mamma/S. Isabel Dacre*
Gift of the artist (1932.16)

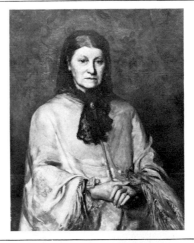

COLONEL VOLBERT
?*c.*1865–70

Oil on panel
$23 \cdot 7 \times 21 \cdot 1$ ($9\frac{5}{16} \times 8\frac{5}{16}$)
s(blc): *S I D*
Gift of the artist (1932.17)

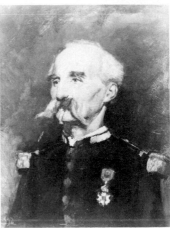

THE WALLS OF SIENA

Oil on canvas
$23 \cdot 1 \times 28$ $(9\frac{1}{8} \times 11)$
s(brc): *S I Dacre.*
Miss Florence J. Chapman gift
(1942.73)

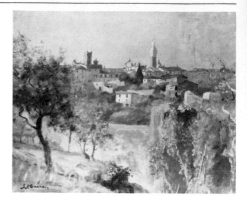

GATEWAY AT SIENA

Oil on canvas
$31 \cdot 7 \times 23 \cdot 6$ $(12\frac{1}{2} \times 9\frac{5}{16})$
s(brc): *S. Isabel Dacre.*
Miss Florence J. Chapman gift
(1942.74)

ASSISI FROM THE CITY WALLS

Oil on canvas
$53 \cdot 8 \times 64 \cdot 8$ $(21\frac{1}{8} \times 25\frac{1}{2})$
s(blc): *S. Isabel Dacre*
Miss Bertha Edgar gift (1943.67)

Nathaniel Dance
1735–1811

THOMAS DAWSON, LORD CREMORNE
(1725–1813)

Oil on canvas
$51 \cdot 4 \times 42$ ($20\frac{1}{4} \times 16\frac{1}{2}$)
Unsigned
Purchased (1905.27)

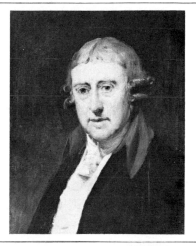

Attributed to Nathaniel Dance

A COUNTRY GENTLEMAN
(formerly called DR. CHARLES
BURNEY)
*c.*1770

Oil on canvas
$91 \cdot 7 \times 71 \cdot 3$ ($36\frac{1}{8} \times 28\frac{1}{16}$)
Unsigned
Purchased (1934.489)

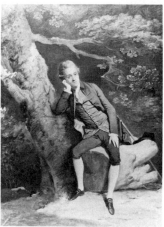

Bartholomew Dandridge
*c.*1690–1754

THE LADIES NOEL
Elizabeth, Jane and Juliana,
daughters of the 4th Earl of
Gainsborough
*c.*1735

Oil on canvas
$118 \times 156 \cdot 7$ ($46\frac{7}{16} \times 61\frac{11}{16}$)
s(blc): *B Dandridge/pinx*
Purchased (1957.161)

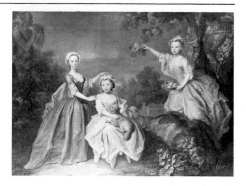

James Hey Davies
1844–1930

YOUNG POACHERS
exh. 1888

Oil on canvas
$71 \cdot 3 \times 107 \cdot 4$ $(28\frac{1}{16} \times 42\frac{1}{4})$
s(brc): *J. Hey. Davies.*
Purchased (1888.1)

STIGGINS LOCK

Oil on canvas
$60 \cdot 8 \times 50 \cdot 8$ $(23\frac{15}{16} \times 20)$
s(br): *J. Hey. Davies.*
George Thomas gift, through the
Royal Manchester Institution
(1917.277)

STUDY OF AN ASH TREE IN WINTER
1883

Oil on canvas
$55 \cdot 2 \times 39 \cdot 2$ $(21\frac{3}{4} \times 15\frac{7}{16})$
s(brc): *J Hey Davies./1883*
Transferred from the Horsfall
Museum (1918.415A)

STUDY OF AN ASH TREE IN SUMMER
1883

Oil on canvas
$55 \cdot 2 \times 39 \cdot 7$ ($21\frac{3}{4} \times 15\frac{5}{8}$)
s(br): *J. HEY. DAVIES./1883*
Transferred from the Horsfall
Museum (1918.415B)

LATE AUTUMN: IRLAM HALL, NEAR
MANCHESTER
1909

Oil on canvas
$50 \cdot 8 \times 76 \cdot 5$ ($20 \times 30\frac{1}{8}$)
s(blc): *Hey Davies / 1909*
Gift of the Executor of George
Thomas (1928.4)

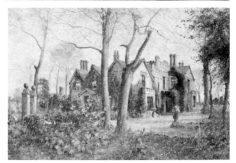

FLINT'S FARM, MOSS SIDE,
MANCHESTER

Oil on canvas
$20 \cdot 5 \times 30 \cdot 5$ ($8\frac{1}{8} \times 12$)
s(blc): *J H D*
W. B. Shaw gift (1934.439)

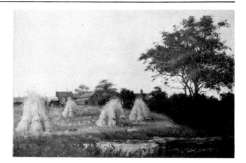

Norman Prescott Davies
active 1880–96

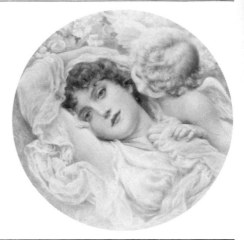

LOVE'S WHISPERS
1896

Oil on canvas
45·7 × 46 (18 × 18⅛)
s(bl): *N. PRESCOTT-DAVIES . 1896.*
James Blair bequest (1917.194)

Henry William Banks Davis
1833–1914

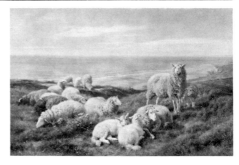

AFTERNOON ON THE CLIFFS
1878

Oil on canvas
50·9 × 76·2 (20 × 30)

s(blc): *H.W.B. Davis/1878.*
James Blair bequest (1917.222)

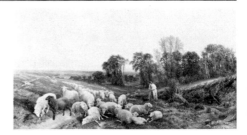

NOONDAY REST
1863

Oil on canvas
28 × 50·9 (11 × 20)
s(blc): *H.W.B. Davis. 1863.*
James Blair bequest (1917.230)

Henry Dawson
1811–1878

ON THE TRENT NEAR NOTTINGHAM
1872

Oil on canvas
81·2 × 126·7 (32 × 49⅞)
s(blc): *18 H Dawson 72* (H D in mon)
Purchased (1891.4)

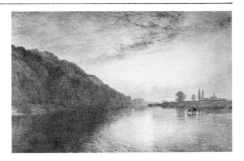

SCOTLAND BRIDGE, RED BANK

Oil on canvas
33·9 × 51·2 (13 5/16 × 20 3/16)
Unsigned
Purchased (1936.125)

Arthur Devis
1711–1787

A YOUNG GENTLEMAN AT A DRAWING
TABLE
(formerly called HORACE WALPOLE)
c.1761

Oil on canvas
63·5 × 50·9 (25 × 20 1/16)
Unsigned
Purchased (1928.89)

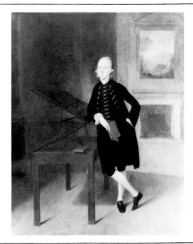

Attributed to Arthur Devis

TWO CHILDREN AND A DOG IN A PARK

Oil on canvas
$62 \cdot 5 \times 75 \cdot 3$ $(24\frac{5}{8} \times 29\frac{5}{8})$
Unsigned
G. Beatson Blair bequest 1941
(1947.100)

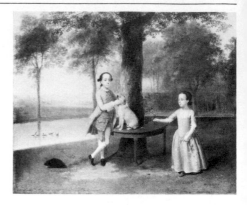

Samuel De Wilde
See Wilde

Peter de Wint
See Wint

Sarah P. Ball Dodson
1847–1906

BUDDING ELMS IN APRIL, MAYFIELD
1901

Oil on canvas
$61 \times 45 \cdot 5$ $(24 \times 17\frac{7}{8})$
s(blc): *S.B. Dodson.*
R. Ball Dodson gift (1920.2)

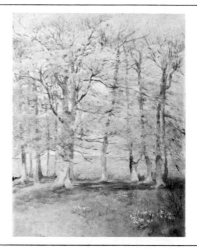

Thomas Millie Dow
1848–1919

A VISION OF SPRING
exh. 1902

Oil on canvas
$137 \cdot 5 \times 183$ $(54\frac{1}{8} \times 72\frac{1}{16})$
s(blc): *T.M.D*
Purchased (1902.15)

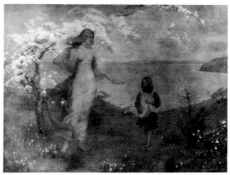

Gainsborough Dupont
See English School, 1759

Sir Alfred East
1849–1913

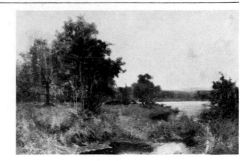

AUTUMN
1887

Oil on canvas
122·3 × 152·5 (40¼ × 60)
s(blc): *ALFRED/EAST*
Purchased (1888.6)

THE SLEEPY RIVER SOMME
1897

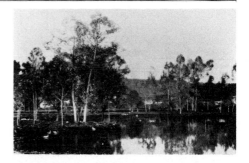

Oil on canvas
101·9 × 153·2 (40⅛ × 60 5/16)
s(brc): *ALFRED/EAST*
Purchased (1898.1)

Sir Charles Lock Eastlake
1793–1865

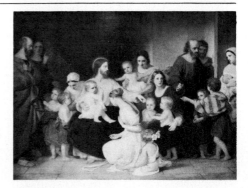

CHRIST BLESSING LITTLE CHILDREN
exh. 1839

Oil on canvas
79 × 103·2 (31 1/16 × 40⅝)
Unsigned
Presented by James Worthington
(1886.1)

James R. Edgar
active 1857–1870

THE MUSHROOM GATHERER

Oil on millboard
$33 \cdot 1 \times 20 \cdot 9 \, (13 \times 8\frac{1}{4})$
s(blc): *J R Edgar* (J R in mon)
Miss Florence Harrison bequest
(1971.40)

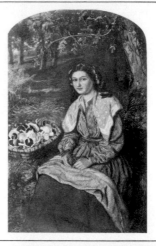

THOMAS (GROSVENOR) EGERTON, 2ND
EARL OF WILTON(1799–1882)
1857

Oil on millboard
$38 \cdot 2 \times 32 \cdot 3 \, (15\frac{1}{16} \times 12\frac{13}{16})$
s(brc): *J. Edgar./1857*
Purchased (1973.270)

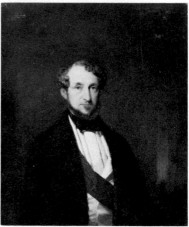

Edwin Edwards
1823–1879

OAK FOREST AT LUDLOW
1866

Oil on canvas
$65 \cdot 4 \times 144 \cdot 2 \, (25\frac{3}{4} \times 56\frac{3}{4})$
s(blc): *Edwin Edwards. 66*
Mrs E. Ruth Edwards gift (1905.25)

Augustus Leopold Egg
1816–1863

A WALK ON THE BEACH
(formerly called AT THE SEASIDE)
c.1855–60

Oil on panel
35·5 × 24·5 (14 × 9⅝)
Unsigned
Purchased (1947.446)

Edwin Ellis
1841–1895

THE HAVEN UNDER THE HILL
(Anglesey)
?1885

Oil on canvas
91·3 × 183·2 (35 15⁄16 × 72 1⁄8)
s(blc): *E. ELLIS.*
Purchased (1885.26)

Alfred Edward Emslie
1848–1918

HENRY DUNCKLEY (1823–1896)
Editor of the 'Manchester Examiner
and Times' 1855–1889
1889

Oil on canvas
106 × 78 (41¾ × 30 11⁄16)
s(blc): *A E. EMSLIE. 1889*
Miss Helena Dunckley gift (1905.1)

English School, 1602

(formerly attributed to Marcus Gheeraerts the Elder)

WILLIAM CHADERTON
(*c.*1539–1608)
Bishop of Chester 1579–95; Bishop of Lincoln 1595–1608

Oil on panel
78·2 × 61 (30¾ × 24)
Inscr (tlc): A^{no} *1602*
(trc): *AETAT SUAE.63.*
Purchased (1923.32)

English School, *c.*1600
See After Robert Peake the Elder

English School, early 17th century

RALPH WORSLEY OF PLATT HALL,
MANCHESTER
m. Isabel Massey 1620

Oil on canvas
74 × 61 (29⅛ × 24)
Unsigned
Purchased (1946.127)

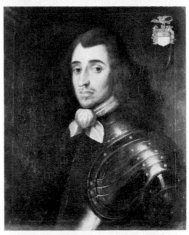

English School, 1633

A LADY HOLDING A JEWEL

Oil on panel
78·5 × 61·3 (30⅞ × 24⅛)
Inscr (tlc): $Æ^{ts}$ *40*
and (trc): *1633*
Miss H. Close bequest through the
N.A-C.F. (1947.8)

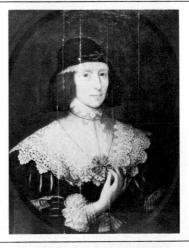

A YOUNG LADY WITH A PLUMED
HEADDRESS

Oil on panel
78×60 ($30\frac{11}{16} \times 23\frac{5}{8}$)
Inscr (tlc): $\textit{Æ}^{ts}_{.}$ 15
and (trc): *1633*
Miss H. Close bequest through the
N.A-C.F. (1947.9)

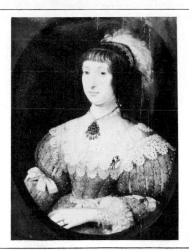

AN OLD LADY IN A RUFF
(in the costume of 1580–1600)

Oil on panel
$76 \cdot 6 \times 65 \cdot 1$ ($30\frac{1}{8} \times 25\frac{5}{8}$)
Inscr (trc): *1633*
 (tlc): $\textit{Æ}^{ts}_{.}$ 54
Miss H. Close bequest through the
N.A-C.F. (1947.10)

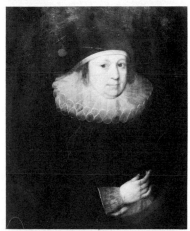

A GENTLEMAN

Oil on panel
$78 \cdot 1 \times 61 \cdot 3$ ($30\frac{3}{4} \times 24\frac{1}{8}$)
Inscr (trc): $\textit{Æ}^{ts}_{.}$ 27 *1633*
Miss H. Close bequest through the
N.A-C.F. (1947.11)

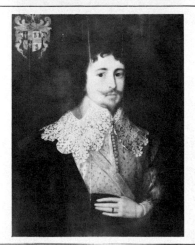

English School, 17th century

BOY WITH HAWK AND DOG

Oil on canvas
$75 \cdot 5 \times 62 \cdot 5$ ($29\frac{3}{4} \times 24\frac{5}{8}$)
Unsigned
Gift of the Executors of C. R.
Dunkerley (1951.392)

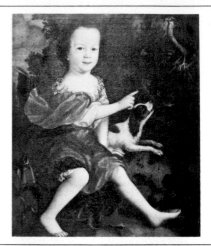

English School, c.1720
(formerly attributed to Thomas
Gainsborough)

A GIRL WITH A PEARL HEADDRESS
c.1710–20

Oil on canvas
$40 \cdot 8 \times 33$ ($16\frac{1}{16} \times 13$)
Unsigned
G. Beatson Blair bequest 1941
(1947.56)

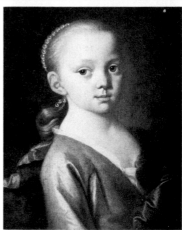

English School, c.1740–50
(formerly attributed to George
Romney)

A LADY IN BLUE AND PINK
(formerly called MRS. AINSLIE)

Oil on canvas
$126 \cdot 5 \times 101 \cdot 4$ ($49\frac{13}{16} \times 39\frac{15}{16}$)
Unsigned
James Blair bequest (1917.177)

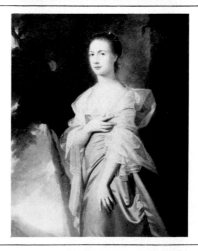

English School, *c.*1750
(formerly attributed to Joseph
Highmore)

THREE CHILDREN IN A PARK

Oil on canvas
91 × 103 (35$\frac{13}{16}$ × 40$\frac{9}{16}$)
Unsigned
Purchased (1950.296)

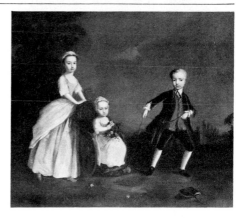

English School, 1759
(formerly attributed to Gainsborough
Dupont)

A LADY, CALLED MRS HUTCHINSON OF
BRISTOL
1759

Oil on canvas
69·5 × 54·4 (27$\frac{3}{8}$ × 21$\frac{7}{16}$)
Unsigned. Inscr (tr): *1759*
James Blair bequest (1917.182)

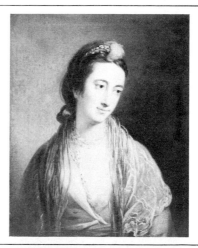

English School, *c.*1770
(formerly attributed to Benjamin
Wilson)

A GENTLEMAN IN A GREEN JACKET

Oil on canvas
60·5 × 50·2 (23$\frac{13}{16}$ × 19$\frac{3}{4}$)
Unsigned
Thomas Balston bequest through the
N.A-C.F. (1968.27)

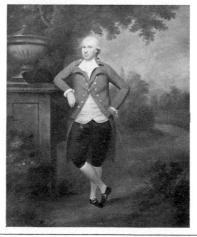

English School, *c.*1770–80

A LADY WITH A HIGH HEADDRESS

Oil on canvas, oval
$29\cdot7 \times 24\cdot8$ ($11\frac{11}{16} \times 9\frac{3}{4}$)
Unsigned
Sir Edward Marsh bequest through
the N.A-C.F. (1953.114)

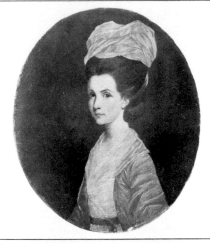

English School, *c.*1775

TWO SISTERS

Oil on canvas
$44\cdot8 \times 35\cdot8$ ($17\frac{5}{8} \times 14\frac{1}{8}$)
Unsigned
Mrs Louisa Mary Garrett bequest
(1936 204)

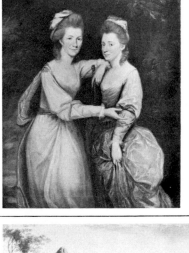

English School, 18th century
(formerly attributed to Richard
Wilson)

THE HOUSE BY THE STREAM

Oil on canvas
$35\cdot7 \times 54\cdot2$ ($14\frac{1}{16} \times 21\frac{3}{8}$)
Unsigned
Dr Jane Walker bequest (1939.18)

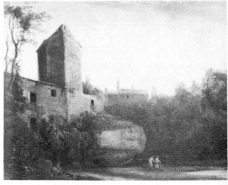

English School, late 18th century
(formerly attributed to George
Stubbs)

HORSE AND DOG IN A LANDSCAPE

Oil on canvas
55×61 ($21\frac{5}{8} \times 24$)
Unsigned
Mrs Robert Hatton gift (1908.39)

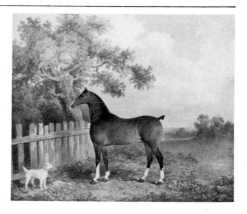

English School, *c.*1780–90

A HORSE WITH GROOM AND DOG IN
PLATT FIELDS, MANCHESTER

Oil on canvas
$87 \cdot 3 \times 102 \cdot 5$ ($34\frac{3}{8} \times 40\frac{3}{8}$)
Unsigned
Mrs C. Tindal-Carill-Worsley gift
(1963.296)

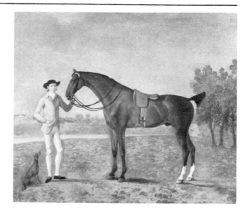

English School, *c.*1800

HUNTER IN STABLE

Oil on canvas
$58 \cdot 5 \times 76 \cdot 2$ ($23\frac{1}{16} \times 30$)
s(on bucket): *WH.*
G. Beatson Blair bequest 1941
(1947.97)

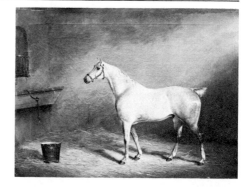

English School, *c.*1800–10

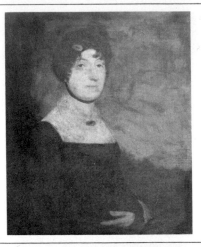

MRS. HENRY BARTON MARSDEN

Oil on canvas
75·6 × 63 (29¾ × 24¹³⁄₁₆)
Unsigned
Miss D. Hartley-Pearson gift (1964.71)

HENRY BARTON MARSDEN
Manchester banker

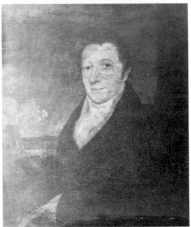

Oil on canvas
75·6 × 63·5 (29¾ × 25)
Unsigned
Miss D. Hartley-Pearson gift (1964.70)

English School, *c.*1810–20

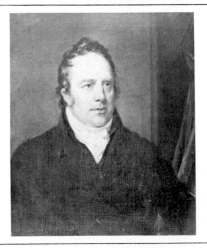

SAMUEL ASHTON OF MIDDLETON
(d. 1833)
An Hereditary Governor of the
Royal Manchester Institution
1824–33

Oil on canvas
76·6 × 63·5 (30⅛ × 25)
Unsigned
F. Ashton-Gwatkin gift (1964.275)

English School, *c.*1820–25

UNIDENTIFIED MILL SCENE
(formerly called VIEW OF OLD
MANCHESTER)

Oil on canvas
65·5 × 91·1 (25¾ × 35⅞)
Unsigned
J.D. Hughes gift (1938.473)

English School, early 19th century
(formerly attributed to J. M. W.
Turner)

POPE'S HOUSE, TWICKENHAM

Oil on canvas
37·6 × 57·3 (14¹³⁄₁₆ × 22⁹⁄₁₆)
Unsigned
James Blair bequest (1917.181)

RIVER SCENE WITH COWS AND TIMBER
WAGGONS

Oil on canvas
79·5 × 100·2 (31⁵⁄₁₆ × 39½)
Unsigned
Mrs James Worthington bequest
(1905.2)

ON THE RIVER THAMES (VIEW OF
ST PAUL'S CATHEDRAL)

Oil on canvas
$25\cdot3\times33$ $(9\frac{15}{16}\times13)$
Unsigned
James Blair bequest (1917.166)

English School, early 19th century
(formerly attributed to William Etty)

VENUS RISING FROM THE SEA

Oil on canvas
$68\cdot4\times54\cdot9$ $(26\frac{15}{16}\times21\frac{5}{8})$
Unsigned
Sir Charles E. Swann gift (1917.272)

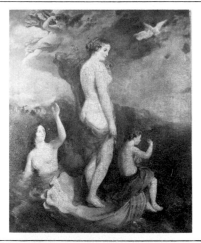

English School, c.1850–70

EDMUND BUCKLEY (1780–1867)
Industrialist; Boroughreeve of
Manchester 1834–5; M.P. 1841–7;
Chairman of the Directors of the
Manchester Royal Exchange 1857–61

Oil on canvas
$110\cdot4\times87\cdot2$ $(43\frac{1}{2}\times34\frac{5}{16})$
Unsigned
Manchester Royal Exchange gift
1968.241)

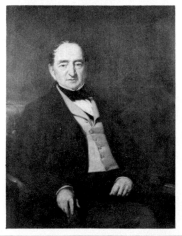

English School, 19th century

MURRAY GLADSTONE (1816–1875)
Chairman of the Directors of the
Manchester Royal Exchange 1865–75

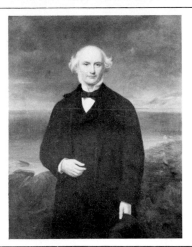

Oil on canvas
$142 \times 112\cdot3$ $(55\frac{7}{8} \times 44\frac{3}{16})$
Unsigned
Manchester Royal Exchange gift
(1968.242)

English School, 1877

INTERIOR OF THE MANCHESTER
ROYAL EXCHANGE
1877

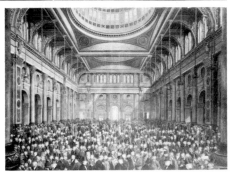

Oil on canvas
$153\cdot4 \times 215\cdot5$ $(60\frac{3}{8} \times 84\frac{7}{8})$
Unsigned
Manchester Royal Exchange gift
(1968.245)

English School
See also Joseph Wright of Derby

William Etty
1787–1849

THE SIRENS AND ULYSSES
(from Pope's translation of the
'Odyssey', book 12)
exh. 1837

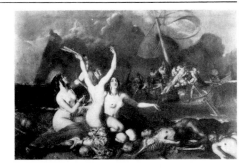

Oil on canvas
$297 \times 442\cdot5$ (117×174)
Unsigned
Transferred from the Royal
Manchester Institution (1882.3)

THE STORM
1829–30

Oil on canvas
$91 \times 104 \cdot 5$ $(35\frac{13}{16} \times 41\frac{1}{8})$
Unsigned
Transferred from the Royal
Manchester Institution (1882.4)

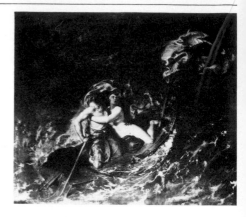

THE WARRIOR ARMING (GODFREY DE
BOUILLON)
1833–4

Oil on canvas
$89 \times 74 \cdot 4$ $(35\frac{1}{16} \times 29\frac{5}{16})$
Unsigned
Sir Joseph Whitworth gift (1882.145)

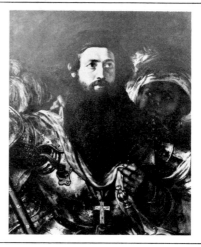

THE DESTROYING ANGEL AND
DAEMONS OF EVIL INTERRUPTING
THE ORGIES OF THE VICIOUS AND
INTEMPERATE
(also called THE DESTRUCTION OF
THE TEMPLE OF VICE and THE LAST
JUDGEMENT)
1822–32

Oil on paper on canvas
$101 \cdot 9 \times 127 \cdot 8$ $(40\frac{1}{8} \times 50\frac{5}{16})$
Unsigned
Sir Joseph Whitworth gift (1882.146)

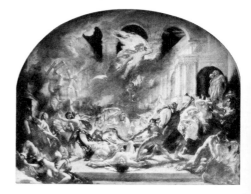

SELF-PORTRAIT
1825

Oil on paper on canvas
$43 \times 33 \cdot 2$ $(16\frac{15}{16} \times 13\frac{1}{16})$
Unsigned
Sir Joseph Whitworth gift (1882.147)

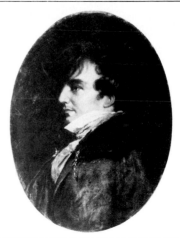

STUDY OF A PEACOCK

Oil on millboard
$59 \cdot 5 \times 82 \cdot 1$ $(23\frac{7}{16} \times 32\frac{5}{16})$
Unsigned
Sir Joseph Whitworth gift (1882.148)

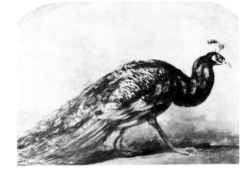

ANDROMEDA AND PERSEUS
after 1840

Oil on canvas
$76 \times 63 \cdot 5$ $(29\frac{15}{16} \times 25)$
Unsigned
George Walthew gift (1894.4)

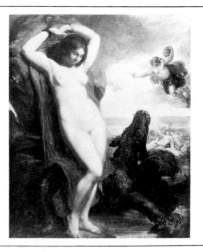

THE BATHER 'AT THE DOUBTFUL
BREEZE ALARMED'
(also called MUSIDORA)
after 1843

Oil on canvas
$35 \cdot 2 \times 24 \cdot 8$ ($13\frac{7}{8} \times 9\frac{3}{4}$)
Unsigned
James Gresham bequest (1917.261)

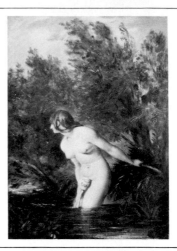

VENUS AND HER DOVES
1836

Oil on canvas
$64 \cdot 9 \times 61$ ($25\frac{9}{16} \times 24$)
Unsigned
Lloyd Roberts bequest (1920.528)

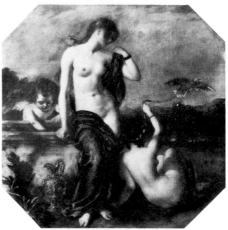

SEATED MALE MODEL

Reverse: two unfinished studies of
female nudes for ANDROMEDA

Oil on millboard
$92 \cdot 1 \times 63 \cdot 4$ ($36\frac{1}{4} \times 24\frac{15}{16}$)
Unsigned
Frank Hindley Smith bequest
(1940.3)

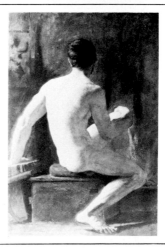

THE HON. MRS CAROLINE NORTON
(1808–1877) AND HER SISTERS
c.1847

Oil on canvas, oval
35·5 × 44·5 (14 × 17½) oval
Unsigned
G. Beatson Blair bequest 1941
(1947·74)

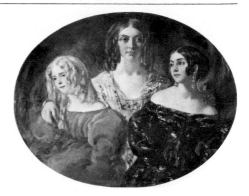

'AN ISRAELITE INDEED'
exh. 1847

Oil on millboard
66·7 × 50·3 (26¼ × 19¹³⁄₁₆)
Unsigned
G. Beatson Blair bequest 1941
(1947·99)

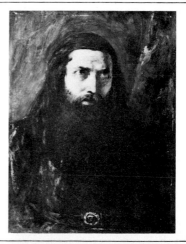

Follower of William Etty

RECLINING MODEL

Oil on panel
47·4 × 60·3 (18¹¹⁄₁₆ × 23¾)
Unsigned
H.C. Coleman gift (1928.117)

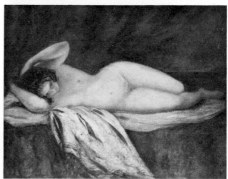

William Etty
See also English School, early 19th
century

Thomas Faed
1826–1900

EVANGELINE

Oil on canvas, arched top
38×31 $(15 \times 12\frac{1}{4})$
s(brc): *Faed*
James Gresham bequest (1917.256)

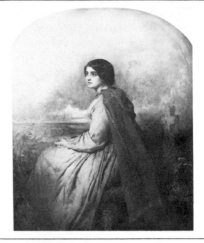

David Farquharson
1839/40–1907

SUMMER'S EVE
1895

Oil on canvas
$152 \cdot 9 \times 229 \cdot 2$ $(60\frac{3}{16} \times 90\frac{3}{16})$
s(blc): *David Farquharson/95*
Purchased (1895.4)

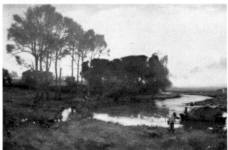

Joseph Farquharson
1846–1935

'THE WEARY WASTE OF SNOWS'
exh. 1898

Oil on canvas
122×183 (48×72)
s(blc): *J. Farquharson*
Purchased (1898.8)

'THE SUN HAD CLOSED THE WINTER DAY'
exh. 1904

Oil on canvas
$43 \cdot 3 \times 33 \cdot 7$ ($17\frac{1}{16} \times 13\frac{5}{16}$)
s(blc): *J. Farquharson.*
James Blair bequest (1917.205)

MARKET ON THE NILE
*c.*1893

Oil on canvas
$43 \cdot 3 \times 69 \cdot 1$ ($17\frac{1}{16} \times 27\frac{3}{10}$)
s(blc): *J. Farquharson*
Purchased (1924.27)

A WINTER MORNING
1901

Oil on canvas
$81 \cdot 2 \times 121 \cdot 3$ ($31\frac{15}{16} \times 47\frac{3}{4}$)
s(brc): *J. Farquharson 1901*
John E. Yates bequest (1934.394)

Benjamin Rawlinson Faulkner
1787–1849

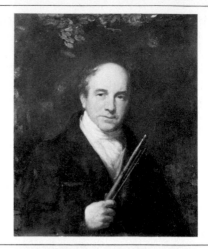

ROBERT HINDLEY (1771–1855)
Brewer; Boroughreeve of Salford
1814; an Hereditary Governor of the
Royal Manchester Institution
1824–55

Oil on canvas
$76·5 \times 63·8$ ($30\frac{1}{8} \times 25\frac{1}{8}$)
Unsigned
Transferred from the Royal
Manchester Institution (1882.21)

James Fellowes
active 1710–1730

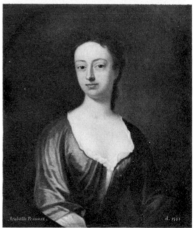

ARABELLE PENNANT (d.1744)
1735

Oil on canvas
$76·2 \times 63$ ($30 \times 24\frac{13}{16}$)
Inscr (blc): *Arabelle Pennant* and
(brc): *d.1744*
G. Beatson Blair bequest 1941
(1947.134)

William Gouw Ferguson
*c.*1633–after ~~1965~~ 1695

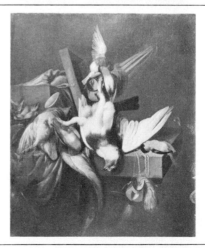

STILL LIFE WITH DEAD PIGEON,
FINCHES AND FALCONS' HOODS

Oil on canvas
$73·1 \times 59·7$ ($28\frac{3}{4} \times 23\frac{1}{2}$)
s(br): *W.G. Ferguson. fc.*
Purchased (1965.309)

Anthony van Dyke Copley Fielding
1787–1855

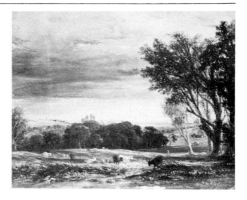

HURSTMONCEAUX CASTLE, SUSSEX
?exh.1835

Oil on panel
20·3 × 25·8 (8 × 10⅛)
Unsigned
James Blair bequest (1917.53)

Attributed to Anthony van Dyke Copley Fielding

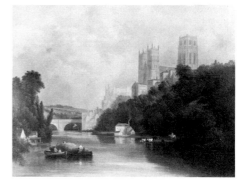

DURHAM CATHEDRAL

Oil on canvas
71·1 × 91·4 (28 × 36)
Unsigned
G. Beatson Blair bequest 1941
(1947.141)

Sir (Samuel) Luke Fildes
1843–1927

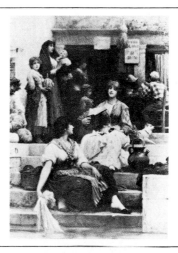

VENETIANS
1885

Oil on canvas
231·5 × 166·1 (91⅛ × 65⅜)
s(blc): *Luke Fildes/1885*
Purchased (1885.23)

A DEVOTEE
*c.*1908

Oil on canvas
63·8 × 48·5 (25⅛ × 19⅛)
s(brc): *Luke Fildes*
James Blair bequest (1917.200)

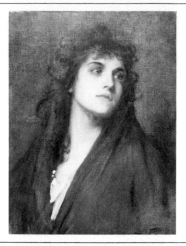

CARINA
1910

Oil on canvas
63·2 × 47·9 (24⅞ × 18⅞)
s(blc): *Luke Fildes 1910.*
James Blair bequest (1917.208)

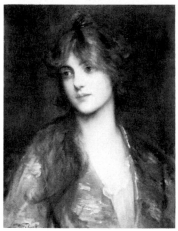

(William) Mark Fisher
1841–1923

FEN MEADOWS WITH CATTLE
1877

Oil on canvas
124 × 183·6 (48¹³⁄₁₆ × 72⁵⁄₁₆)
s(blc): *Mark Fisher 1877*
Gift of the family of Robert Barclay
(1906.102)

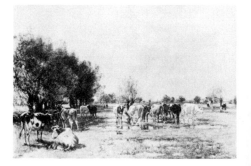

CATTLE IN A MEADOW

Oil on canvas
$35 \cdot 5 \times 41 \cdot 4$ ($14 \times 16\frac{5}{16}$)
s(blc): *Mark Fisher*
Lloyd Roberts bequest (1920.531)

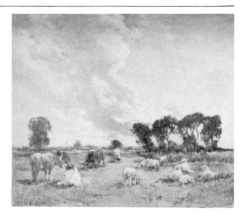

HORSES BY A LOCK

Oil on canvas
$80 \times 131 \cdot 8$ ($31\frac{1}{2} \times 51\frac{7}{8}$)
s(brc): *Mark Fisher*
Lloyd Roberts bequest (1920.533)

POND AND WILLOWS
(Widdington, Essex)
*c.*1898

Oil on canvas
$86 \times 119 \cdot 4$ ($33\frac{7}{8} \times 47$)
s(brc): *Mark Fisher*
W. H. Wood gift (1924.7)

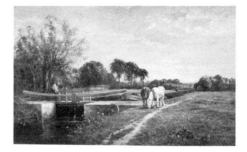

CATTLE

Oil on canvas
35×50 ($13\frac{3}{4} \times 19\frac{11}{16}$)
s(brc): *Mark Fisher*
Alderman Frederick Todd gift
(1925.58)

ON THE ROAD TO NEWPORT
1895

Oil on canvas
$77 \cdot 2 \times 92 \cdot 2$ ($30\frac{3}{8} \times 36\frac{5}{16}$)
s(blc): *Mark Fisher 95*
Sir Christopher Needham bequest
(1942.72)

LANDSCAPE WITH RIVER AND
CATTLE

Oil on canvas
$45 \cdot 2 \times 65 \cdot 6$ ($17\frac{13}{16} \times 25\frac{13}{16}$)
s(blc): *Mark Fisher*
G. Beatson Blair bequest 1941
(1947.128)

UNDER THE OLIVES

Oil on canvas
60·3 × 82·1 (23¾ × 32⁵⁄₁₆)
s(blc): *Mark Fisher*
G. Beatson Blair bequest 1941
(1947.136)

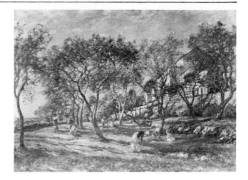

Henry J. Fleuss
active 1847–74

THOMAS (GROSVENOR) EGERTON,
2ND EARL OF WILTON (1799–1882)
1872

Oil on millboard 2 7 × 2 2 (10 ⅝ × 8 ⅝)
~~13·6 × 18·9 (9⁵⁄₁₆ × 7⁷⁄₁₆)~~
Inscr (verso): *The Earl of Wilton/HF/
Jan. 1872*
Purchased (1972.46)

Myles Birket Foster
1825–1899

THE BROOK
exh. 1874

Oil on canvas
77·5 × 62·4 (30½ × 24⁹⁄₁₆)
s(blc): *BF* (mon)
John E. Yates bequest (1934.400)

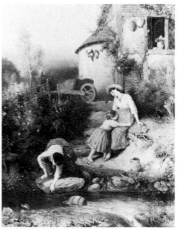

William Powell Frith
1819–1909

THE DERBY DAY (1856)
1893–4

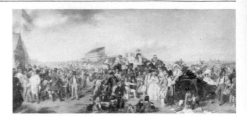

Oil on canvas
102·3 × 234·4 (40¼ × 92¼)
s(brc): *W.P. Frith. 1893–94*
James Gresham gift (1896.4)

CLAUDE DUVAL
(from Macaulay's 'History of
England')
1859–60

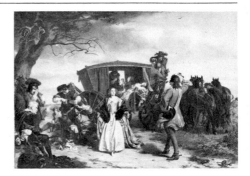

Oil on canvas
108·8 × 153 (42 13/16 × 60¼)
Unsigned
James Gresham bequest (1917.270)

THE SQUIRE'S BOXING LESSON
(from Goldsmith's 'The Vicar of
Wakefield')
1860

Oil on canvas
24·3 × 40 (9 9/16 × 15¾)
s(blc): *W P Frith. 1860*
Lloyd Roberts bequest (1920.534)

MME JOURDAIN DISCOVERS HER
HUSBAND AT THE DINNER WHICH HE
GAVE TO THE BELLE MARQUISE AND
THE COUNT DORANTE
(from Molière's 'Le Bourgeois
Gentilhomme')

Oil on millboard
18·4 × 23·8 (7¼ × 9⅜)
Unsigned
Lloyd Roberts bequest (1920.535)

QUEEN ELIZABETH I AND COURTIERS

Oil on paper on canvas
23·8 × 38 (9⅜ × 14¹⁵⁄₁₆)
Unsigned
Lloyd Roberts bequest (1920.548)

Thomas Gainsborough
1727–1788

A YOUNG GENTLEMAN
(formerly called JAMES WOLFE, LATER
GENERAL WOLFE)

Oil on canvas
76·5 × 63·5 (30⅛ × 25)
Unsigned
Purchased (1900.14)

LANDSCAPE WITH SHEEP

Oil on canvas
$30 \cdot 1 \times 35 \cdot 2$ $(11\frac{13}{16} \times 13\frac{7}{8})$
Unsigned
F. J. Nettlefold gift (1948.48)

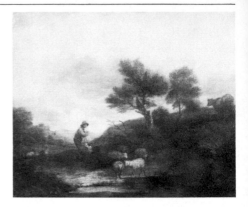

(formerly attributed to William Hoare)

MRS PRUDENCE RIX (1708–1783)
(also called MARY RIX)
?$c.1755$

Oil on canvas
$75 \cdot 7 \times 63 \cdot 5$ $(29\frac{13}{16} \times 25)$
Unsigned
B. W. Blakely bequest (1950.61)

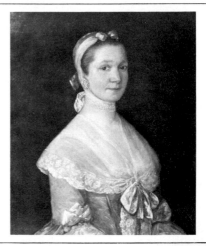

LANDSCAPE WITH FIGURES
?$c.1786$

Oil on canvas
$62 \cdot 5 \times 76 \cdot 2$ $(24\frac{5}{8} \times 29\frac{15}{16})$
Unsigned
Purchased (1950.66)

Thomas Gainsborough
See also English School, $c.1720$

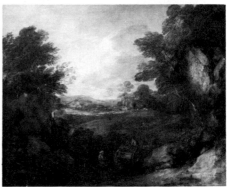

Norman Garstin
1847–1926

THE CARD PLAYERS
1908

Oil on canvas
$37 \cdot 5 \times 32 \cdot 1$ ($30\frac{1}{2} \times 36\frac{1}{4}$)
s(br): *NORMAN GARSTIN*
Mrs Garstin gift (1927.48)

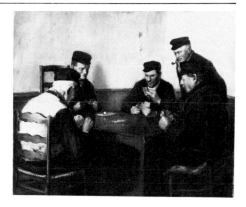

Marcus Gheeraerts the Elder
See English School, 1602

Sir John Gilbert
1817–1897

A VENETIAN COUNCIL OF WAR
1891–2

Oil on canvas
87×112 ($34\frac{1}{4} \times 44\frac{1}{8}$)
s(brc): *J G 1891.2* (mon)
Gift of the artist (1893.5)

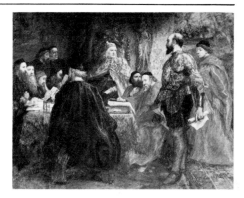

BREAKING UP THE ENCAMPMENT
1887–8

Oil on canvas
$122 \times 152 \cdot 6$ ($48 \times 60\frac{1}{16}$)
s(bl): *JG 1887,8* (mon)
Gift of the artist (1893.6)

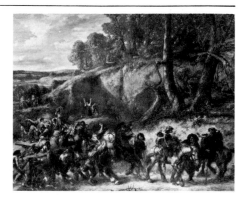

'ONWARD'
1890

Oil on canvas
152·8 × 122·1 (60⅛ × 48 1/16)
s(blc): *JG/1890* (mon)
Gift of the artist (1893.7)

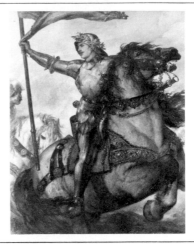

DON SANCHO PANZA, GOVERNOR OF
BARATARIA
1875

Oil on canvas
30·5 × 25·6 (12 × 10 1/16)
s(blc): *JG/1875* (mon)
Gift of the artist (1893.8)

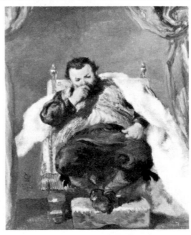

GIPSIES
1882–4

Oil on canvas
52 × 64·8 (20½ × 25½)
s(blc): *JG 1882–4* (mon)
Gift of the artist (1893.9)

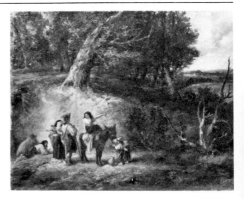

Frederick Goodall
1822–1904

THE WATER OF THE NILE
exh. 1893

Oil on canvas
131·5 × 305 (51¾ × 120¼)
s(bl): *FG 1893* (mon)
Frederick Smallman gift (1893.22)

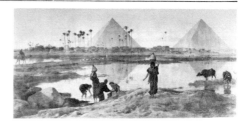

POULTRY
1842

Oil on millboard
25·4 × 34·9 (10 × 13¾)
s(blc): *F. Goodall/1842*
Sir Joseph Whitworth bequest
(1896.10)

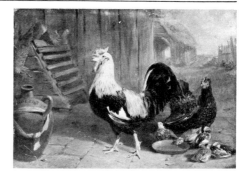

Sir John Watson Gordon
1790–1864
(formerly attributed to Colvin Smith)

SIR WALTER SCOTT (1771–1832)
Novelist and poet

Oil on canvas
76·2 × 63·7 (30 × 25⅛)
Unsigned
Purchased (1903.1)

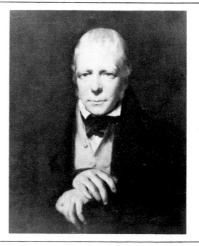

George Gower
c.1540–1596

MARY CORNWALLIS
m. William Bourchier, Earl of Bath;
marriage annulled before 1583; will
proved 1627
c.1580–5

Oil on panel
117·2 × 94 (46⅛ × 37)
Unsigned. Inscr (tlc): *Mary
Cornwallis, Wife of/the Earl of Bath*
Purchased (1953.112)

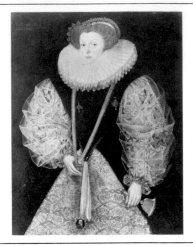

Peter Graham
1836–1921

A SPATE IN THE HIGHLANDS
1866

Oil on canvas
120 × 176·8 (47¼ × 69⅝)
s(brc): *P. Graham/1866*
Sir William Cunliffe Brooks gift
(1901.3)

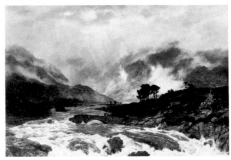

HIGHLAND CATTLE, PERTHSHIRE
1901

Oil on canvas
60·9 × 91·4 (24 × 36)
s(brc): *Peter Graham/1901*
James Blair bequest (1917.201)

THE SEA-BIRDS' DOMAIN
1902

Oil on canvas
76·5 × 63·5 (30⅛ × 25)
s(brc): *Peter Graham/1902*
James Blair bequest (1917.216)

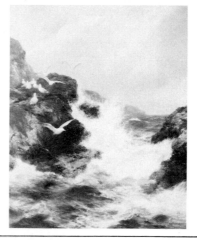

Walter Greaves
1846–1930

CHELSEA REGATTA

Oil on canvas
91·8 × 191·7 (36⅛ × 75½)
s(l, on wooden shed): *W. Greaves*
Purchased (1922.8)

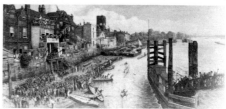

James Astbury Hammersley
1815–1869

MOUNTAINS AND CLOUDS – A SCENE
FROM THE TOP OF LOUGHRIGG,
WESTMORELAND
exh. 1850

Oil on canvas
131·1 × 183·5 (51⅝ × 72¼)
Unsigned
Transferred from the Royal
Manchester Institution (1882.23)

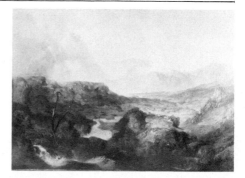

George Henry Harlow
1787–1819

THE SISTERS

Oil on canvas
86×68 ($33\frac{7}{8} \times 26\frac{3}{4}$)
Unsigned
James Blair bequest (1917.186)

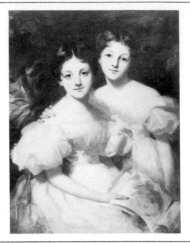

Frederick William Hayes
1848–1918

ON THE GLASLYN RIVER
1883

Oil on paper pasted to board
$44 \times 59 \cdot 5$ ($17\frac{5}{16} \times 23\frac{7}{16}$)
Unsigned
Gerald R. Hayes gift (1921.17)

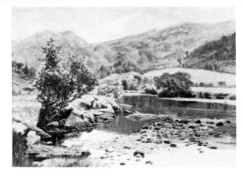

CNICHT, CARNARVONSHIRE
1880

Oil on paper on millboard
$59 \times 42 \cdot 9$ ($23\frac{1}{4} \times 16\frac{7}{8}$)
Unsigned
Gerald R. Hayes gift (1921.18)

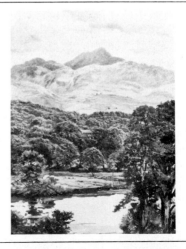

George Hayes
1823–1895

THE VISIT OF QUEEN VICTORIA AND
PRINCE ALBERT TO MANCHESTER
IN 1851
1876

Oil on canvas
43·2 × 60 (17 × 23⅝)
s(brc): *G. Hayes/1876*
Gift of the City Treasurer (1957.171)

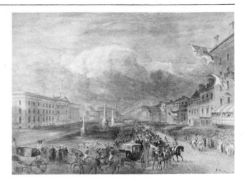

Charles Napier Hemy
1841–1917

OLD PUTNEY BRIDGE
1882

Oil on canvas
92·3 × 138·4 (36$\frac{5}{16}$ × 54½)
s(blc): *C. Napier Hemy 1882.*
Purchased (1883.28)

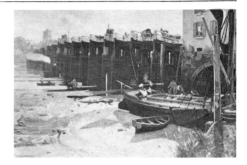

GOD'S HOUSES, MAESTRICHT
1870

Oil on canvas
59 × 89·3 (23¼ × 35$\frac{3}{16}$)
s(brc): *C N Hemy/1870*
Mrs T. T. Greg gift (1919.11)

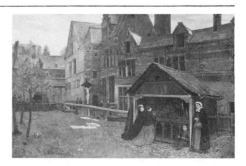

Sir Hubert von Herkomer
1849–1914

HARD TIMES, 1885

Oil on canvas
$86 \cdot 5 \times 112 \ (34\frac{1}{16} \times 44\frac{1}{8})$
s(blc): *H H 85*
Purchased (1885.24)

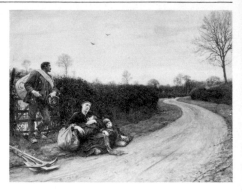

John Frederick Herring, Senior
1795–1865

DUCKS BY A STREAM
1863

Oil on panel
$25 \cdot 1 \times 30 \cdot 4 \ (9\frac{7}{8} \times 12)$
s(on leaf, l of centre): *J.F. Herring/
Sen.ʳ/1863*
John E. Yates bequest (1934.404)

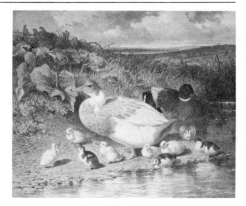

SPRINGTIME – PLOUGHING
1856

Oil on canvas
$66 \cdot 7 \times 112 \cdot 4 \ (26\frac{1}{4} \times 44\frac{1}{4})$
s(r, on box of roller): *J.F. Herring
Sen' / 1856*
G. Beatson Blair bequest 1941
(1947.139)

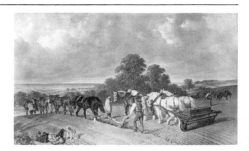

George Elgar Hicks
1824–1914

MOTHER AND CHILD
1873

Oil on canvas
91·5 × 71·3 (36 × 28 $\frac{1}{16}$)
s(brc): *G.̣ Hicks 1873.*
Lloyd Roberts bequest (1920.526)

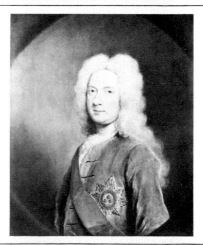

Joseph Highmore
1692–1780

JOHN SIDNEY, 6TH EARL OF
LEICESTER (1680–1737)
1728

Oil on canvas
76·2 × 63·5 (30 × 25)
s(bl): *J. Highmore pinx.̣/A.̣ 1728*
Purchased (1963.268)

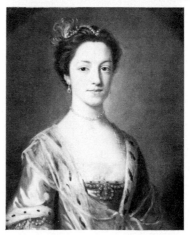

Follower of Joseph Highmore

MISS TAYLOR

Oil on canvas
60·5 × 50·5 (23 $\frac{13}{16}$ × 19 $\frac{7}{8}$)
Unsigned
G. Beatson Blair bequest 1941
(1947.83)

Joseph Highmore
See also English School, *c*.1750

Richard Hilder
1813–1852

OKEHAMPTON, DEVON

Oil on panel
$53 \cdot 3 \times 41 \cdot 9$ $(21 \times 16\frac{1}{2})$
s(brc): *R. Hilder 184.* . (illegible)
F. J. Nettlefold gift (1948.50)

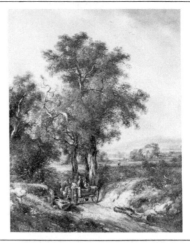

William Hilton
1786–1839

PHAETON

Oil on canvas
$63 \cdot 5 \times 76 \cdot 2$ (25×30)
Unsigned
Transferred from the Royal
Manchester Institution (1882.18)

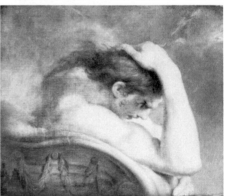

Attributed to William Hoare
1707–1792

FRANCES RIX (1724–1797)
m. William Blakely 1755
*c.*1736

Oil on canvas
$76 \cdot 2 \times 64 \cdot 1$ $(30 \times 25\frac{1}{4})$
Unsigned
B. W. Blakely bequest (1950.62)

William Hoare
See also Thomas Gainsborough

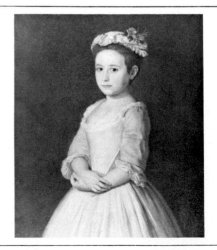

William Hodges
1744–1797

VIEW OF CALCUTTA

Oil on canvas
$62 \cdot 9 \times 94 \cdot 8$ ($24\frac{3}{4} \times 37\frac{5}{16}$)
Unsigned
Sir Thomas Barlow gift (1949.104)

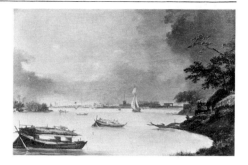

William Hogarth
1697–1764

A GENTLEMAN
1739

Oil on canvas
$76 \cdot 4 \times 63 \cdot 2$ ($30\frac{1}{16} \times 24\frac{7}{8}$)
s(blc): *W HOGARTH/PINX 1739*
Purchased (1928.119)

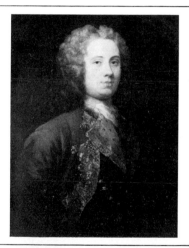

THE POOL OF BETHESDA
*c.*1735

Oil on canvas
$62 \times 74 \cdot 5$ ($24\frac{3}{8} \times 29\frac{5}{16}$)
Unsigned
Purchased (1955.126)

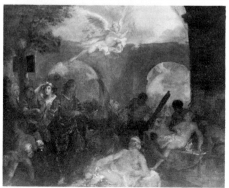

James Holland
1799–1870

LISBON FROM PORTO BRANDAS
1845

Oil on millboard
26.6×33.7 ($10\frac{1}{2} \times 13\frac{5}{16}$)
Inscr(verso): *Lisbon./from Porto Brandâs/Ja.ˢ Holland 1845*
Purchased (1906.3)

VENICE

Oil on canvas
57.5×101.1 ($22\frac{5}{8} \times 39\frac{13}{16}$)
s(on boat at r): *J H* (mon)
James Blair bequest (1917.155)

HERNE BAY, KENT
1855

Oil on millboard
19.6×36.6 ($7\frac{11}{16} \times 14\frac{7}{16}$)
Inscr(verso): *Herne Bay –*
James Holland
1855
James Blair bequest (1917.157)

Nathaniel Hone
1718–1784

SELF-PORTRAIT
1778

Oil on canvas
$75 \times 62 \cdot 6$ $(29\frac{1}{2} \times 24\frac{5}{8})$
s(brc): *Painted by N H/ at Petworth/*
1778 (initials in mon)
Purchased (1928.75)

James Clarke Hook
1819–1907

FROM UNDER THE SEA
1864

Oil on canvas
$108 \cdot 2 \times 82 \cdot 6$ $(42\frac{5}{8} \times 32\frac{1}{2})$
s(brc): *J C H 1864* (mon)
Purchased (1891.8)

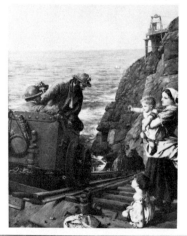

THE DEFEAT OF SHYLOCK
(from Shakespeare's 'The Merchant
of Venice')
1850

Oil on panel
$80 \times 100 \cdot 3$ $(31\frac{1}{2} \times 39\frac{1}{2})$
s(brc): *HOOK. 1850.*
Sir Joseph Whitworth bequest
(1896.11)

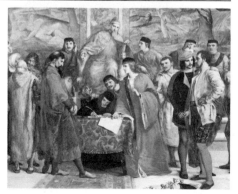

CRABBERS
1876

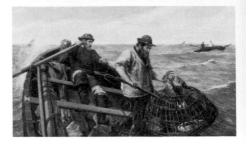

Oil on canvas
77·2 × 132·4 (30⅜ × 52⅛)
s(blc): *18 JCH 76* (mon)
Purchased (1904.6)

John Callcott Horsley
1817–1903

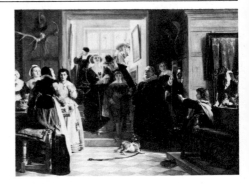

COMING DOWN TO DINNER
1876

Oil on canvas
124·1 × 163 (48⅞ × 64³⁄₁₆)
s(br): *J.C. Horsley. 1876*
Henry Lee bequest (1905.22)

Thomas Hudson
1701–1779

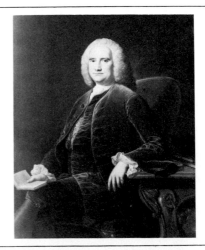

JOHN SHARP, ARCHDEACON OF
DURHAM (d. 1792)
1757

Oil on canvas
124·2 × 100·7 (48⅞ × 39⅝)
s(bl): *T. Hudson/Pinxit 1757*
Thomas Thornhill Shann gift
(1901.8)

Arthur Hughes
1832–1915

OPHELIA
(from Shakespeare's 'Hamlet')
1852

Oil on canvas, arched top
68·7 × 123·8 (27$\frac{1}{16}$ × 48$\frac{3}{4}$)
s(brc): *ARTHUR HUGHES*
Purchased (1955.109)

William Holman Hunt
1827–1910

THE SHADOW OF DEATH
1870–3

Oil on canvas
214·2 × 168·2 (84$\frac{5}{16}$ × 66$\frac{3}{16}$)
s(brc): *18 Whh 70–3 | JERUSALEM*
(initials in mon)
Thomas and William Agnew gift
(1883.21)

THE HIRELING SHEPHERD
(from Shakespeare's 'King Lear', III, 6)
1851

Oil on canvas
76·4 × 109·5 (30$\frac{1}{16}$ × 43$\frac{1}{8}$)
s(blc): *Holman Hunt. 1851. Ewell*
Purchased (1896.29)

THE SCAPEGOAT
(from Isaiah, liii, 4 and Leviticus, xvi, 22)
1854–5

Oil on canvas
$33 \cdot 7 \times 45 \cdot 9$ ($13\frac{1}{4} \times 18\frac{1}{16}$)
s(blc): *Whh* (mon)
Purchased (1906.2)

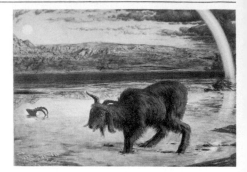

THE LIGHT OF THE WORLD
(from Revelations, iii, 20)
1851–6

Oil on canvas, arched top
$49 \cdot 8 \times 26 \cdot 1$ ($19\frac{5}{8} \times 10\frac{5}{16}$)
s(brc): *Whh* (mon)
Purchased (1912.53)

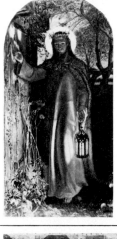

THE LANTERN MAKER'S COURTSHIP
*c.*1854–60

Oil on panel
$29 \cdot 4 \times 18 \cdot 8$ ($11\frac{9}{16} \times 7\frac{3}{8}$)
s(blc): *Whh* (mon)
James Gresham bequest (1917.266)

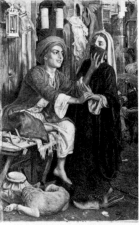

STUDY OF A HEAD (EDITH HOLMAN
HUNT)
1884

Oil on panel
$33 \cdot 5 \times 30 \cdot 7$ $(13\frac{3}{16} \times 12\frac{1}{16})$
s(blc): *W.H.H. 84. to his old friend*
Dr. Q... (illegible) / *Painted on Gesso*
M... (illegible)
Purchased (1920.6)

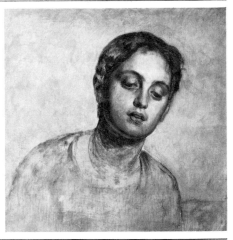

THE LADY OF SHALOTT
(from Tennyson's poem)
*c.*1886–1905

Oil on panel
$44 \cdot 4 \times 34 \cdot 1$ $(17\frac{1}{2} \times 13\frac{7}{16})$
s(blc): *Whh* (mon)
John E. Yates bequest (1934.401)

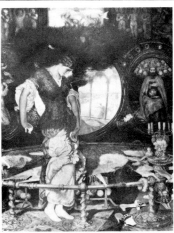

Colin Hunter
1841–1904

THE HERRING MARKET AT SEA
(on Loch Fyne, Argyll)
1884

Oil on canvas
$108 \cdot 3 \times 183 \cdot 5$ $(42\frac{5}{8} \times 72\frac{1}{4})$
s(brc): *Colin Hunter 1884*
Purchased (1884.10)

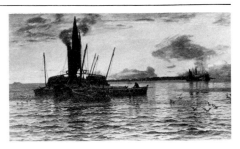

Julius Caesar Ibbetson
1759–1817

CAVE IN ST. CATHERINE'S ROCK,
TENBY, PEMBROKESHIRE

Oil on canvas
$32 \cdot 7 \times 24$ $(12\frac{7}{8} \times 9\frac{7}{16})$
Unsigned
Purchased (1902.4)

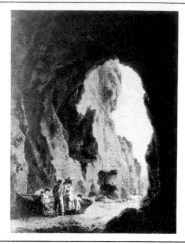

LUDLOW CASTLE, SHROPSHIRE
1792

Oil on canvas
33×46 $(13 \times 18\frac{1}{8})$
s(brc): *J. Ibbetson. p./1792.*
Purchased (1928.118)

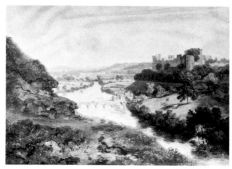

THE GATHERING STORM

Oil on panel
$29 \cdot 5 \times 38$ $(11\frac{5}{8} \times 14\frac{15}{16})$
Unsigned
Harry B. Wood gift (1934.204)

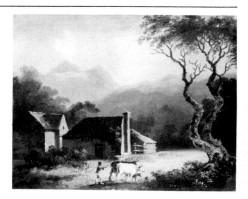

Julius Caesar Ibbetson
1759–1817
and **George Morland**
1763–1804

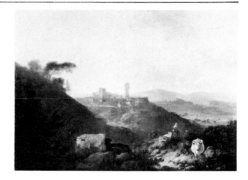

VIEW OF LLANTRISANT,
GLAMORGANSHIRE, FROM THE
WESTWARD
exh. 1791

Oil on canvas
$66 \cdot 6 \times 92 \cdot 4$ $(26\frac{1}{4} \times 36\frac{3}{8})$
s(blc): *J. Ibbetson/ &/G Morland*
Purchased (1903.4)

John Jackson
1778–1831

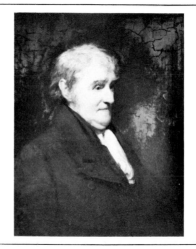

THOMAS STOTHARD (1755–1834)
Painter and book-illustrator
?exh. 1829

Oil on panel
$71 \cdot 7 \times 59 \cdot 7$ $(28\frac{1}{4} \times 23\frac{1}{2})$
Unsigned
Purchased (1909.30)

George Jamesone
See After Daniel Mytens

Charles Jones
1836–1892

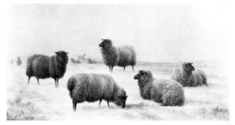

SHEEP IN SNOW
1876

Oil on canvas
$51 \times 96 \cdot 8$ $(20\frac{1}{16} \times 38\frac{1}{8})$
s(brc): *CJ 76* (mon) and verso:
Charles Jones. 1876.
Transferred from the Horsfall
Museum (1918.403)

Louise Jopling (Jopling–Rowe)
1843–1933

SELF-PORTRAIT
1877

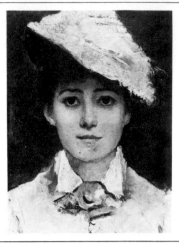

Oil on panel
20·3 × 15 (8 × 5⅞)
s(blc): *Louise Jopling 1877*
Percy G. Trendell gift in memory of
Sir Arthur Trendell (1934.2)

THE PAINTER'S SON
Lindsay M. Jopling, d. 1967

Oil on panel
55·8 × 42·8 (22 × 16⅞)
Unsigned
Mrs Joan Jopling gift (1935.180)

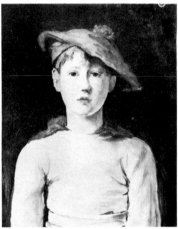

Angelica Kauffman
1741–1807

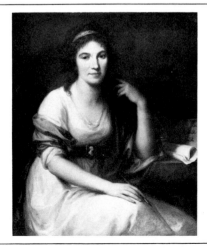

MISS CORNELIA KNIGHT (1757–1837)
(formerly called SELF-PORTRAIT)
1793

Oil on canvas
96 × 80 (37¾ × 31½)
s(br): *Angelica Kauffman./Pinx.*
Romæ/1793 and (on belt clasp):
ANGELICA·KAUFFMAN
Purchased (1901.9)

George Goodwin Kilburne
1839–1924

ON THE STAIRCASE

Oil on panel
$25 \cdot 3 \times 17 \cdot 7$ ($9\frac{15}{16} \times 7$)
s(brc): *G G Kilburne*
James Blair bequest (1917.197)

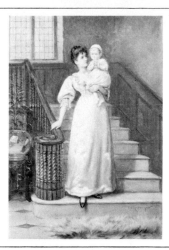

Follower of Sir Godfrey Kneller
1646–1723

JAMES II (1633–1701)

Oil on canvas
$231 \cdot 5 \times 141 \cdot 8$ ($91\frac{1}{8} \times 55\frac{13}{16}$)
Unsigned
Purchased (1961.251)

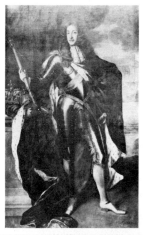

Sir Godfrey Kneller

QUEEN MARY (1917.183)
Now attributed to Wissing (Foreign
Schools Catalogue)

John William Buxton Knight
1842–1908

MIDDAY
?1891

Oil on canvas
102×128 ($40\frac{3}{8} \times 50\frac{3}{8}$)
s(blc): *J Buxton Knight/91.* (or 92)
Purchased (1908.14)

TIDAL BREEZE, GOSPORT, HAMPSHIRE

Oil on canvas
$61 \cdot 5 \times 92$ $(24\frac{3}{16} \times 36\frac{1}{4})$
s(brc): *J. Buxton Knight*
Purchased (1909.6)

HOPPERS
1888

Oil on canvas
$76 \cdot 5 \times 152 \cdot 4$ $(30\frac{1}{8} \times 60)$
s(blc): *J W Buxton Knight/88*
E. A. Knight gift (1931.59)

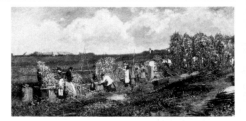

HOP GARDEN

Oil on canvas
$125 \cdot 9 \times 88 \cdot 6$ $(49\frac{9}{16} \times 34\frac{7}{8})$
s(blc): *John W B Knight* and (brc):
J Knight
G. Beatson Blair bequest 1941
(1947.138)

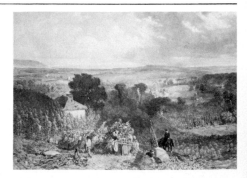

Joseph Knight
1838–1909

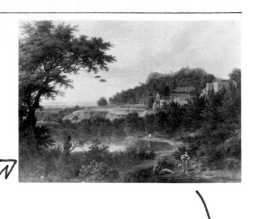

LIFTING MIST
(near Capel Curig, North Wales)
1883

Oil on canvas
$137 \cdot 5 \times 91 \cdot 8$ ($54\frac{1}{8} \times 36\frac{1}{8}$)
s(blc): *J. Knight. 83*
Purchased (1884.9)

George Lambert
1710–1765

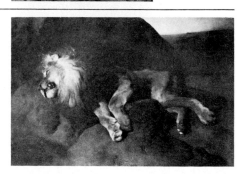

CLASSICAL LANDSCAPE
1747

Oil on canvas
$73 \cdot 6 \times 99 \cdot 4$ ($29 \times 39\frac{1}{8}$)
s(br): *G. Lambert/1747.*
Purchased (1960.330)

George Lambert
See also Thomas Barker of Bath

Sir Edwin Landseer
1802–1873

THE FALLEN MONARCH

Oil on canvas
$177 \cdot 5 \times 270$ ($69\frac{7}{8} \times 106\frac{5}{16}$)
Unsigned
Sir William Agnew, Bart., gift
(1902.2)

BOLTON ABBEY, YORKSHIRE

Oil with pencil on millboard
$25 \cdot 3 \times 35 \cdot 5$ ($9\frac{15}{16} \times 14$)
Unsigned
Lloyd Roberts bequest (1920.543)

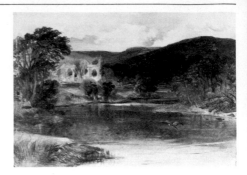

ON THE TILT, PERTHSHIRE
?exh 1826

Oil with pencil on millboard
$25 \cdot 8 \times 35 \cdot 5$ ($10\frac{1}{8} \times 14$)
Unsigned
Lloyd Roberts bequest (1920.554)

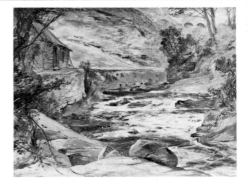

Sir Thomas Lawrence
1769–1830

JAMES CURTIS (1750–1835)
London brewer
c.1803

Oil on canvas
$128 \cdot 7 \times 102 \cdot 7$ ($50\frac{11}{16} \times 40\frac{7}{16}$)
Unsigned
Purchased (1953.441)

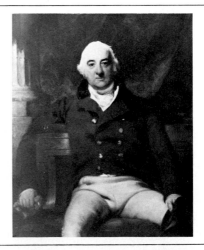

Follower of Sir Thomas Lawrence

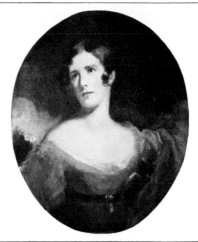

MISS ELIZA CALVERT
b. 1817; m. William Bradley 1833

Oil on canvas
$76 \times 63 \cdot 4$ ($29\frac{15}{16} \times 24\frac{15}{16}$)
Unsigned
G. Beatson Blair bequest 1941
(1947.130)

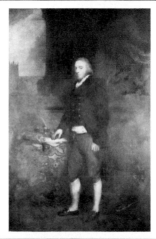

COLONEL THOMAS STANLEY M.P.
(1749–1816)
before 1810

Oil on canvas
$283 \cdot 5 \times 181$ ($111\frac{5}{8} \times 71\frac{1}{4}$)
Unsigned
Manchester Royal Exchange gift
(1968.243)

After Sir Thomas Lawrence

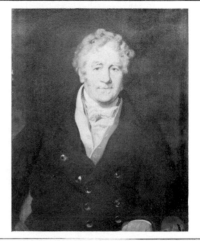

SIR ROBERT PEEL, 1ST BART. (1750–1830)
Manufacturer and M.P.

Oil on canvas
$92 \times 71 \cdot 3$ ($36\frac{1}{4} \times 28\frac{1}{16}$)
Unsigned
Manchester Royal Exchange gift
(1968.240)

Benjamin Williams Leader
1831–1923

STRATFORD-ON-AVON CHURCH AND
LOCK
1883

Oil on canvas
142·5 × 102·7 (56⅛ × 42⅛)
s(blc): *B. W. LEADER. 1883.*
The family of Emil Reiss gift (1913.14)

EVENING'S LAST GLEAM
1899

Oil on canvas
30·6 × 46·2 (12 $\frac{1}{16}$ × 18 $\frac{3}{16}$)
s(blc): *B. W. LEADER. 1899.*
James Blair bequest (1917.213)

GREEN PASTURES AND STILL WATERS
1896

Oil on canvas
50·1 × 76·4 (19¾ × 30 $\frac{1}{16}$)
s(blc): *B. W. LEADER. 1896.*
James Blair bequest (1917.215)

SUNSET ON THE SEVERN
1896

Oil on canvas
30·6 × 46·2 (12 $\frac{1}{16}$ × 18 $\frac{3}{16}$)
s(blc): *B. W. LEADER. 1896.*
James Blair bequest (1917.217)

GORING CHURCH ON THAMES
1898

Oil on canvas
45·9 × 66 (18 $\frac{1}{16}$ × 26)
s(blc): *B. W. LEADER. 1898.*
James Blair bequest (1917.233)

ON THE SEVERN BELOW WORCESTER
1897

Oil on canvas
30·5 × 46 (12 × 18 $\frac{1}{8}$)
s(blc): *B. W. LEADER. 1897.*
James Blair bequest (1917.234)

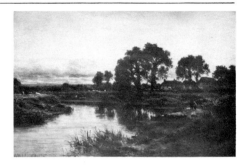

AT EVENING TIME IT SHALL BE LIGHT
1897

Oil on canvas
76·5 × 127·3 (30⅛ × 50⅛)
s(blc): *B. W. LEADER 1897*.
John E. Yates bequest (1934.397)

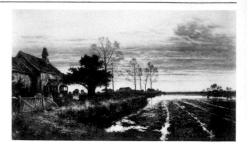

FEBRUARY FILL DYKE
1881

Oil on canvas
76·6 × 122·6 (30$\frac{3}{16}$ × 48¼)
s(blc): *B. W. LEADER. 1881*.
John E. Yates bequest (1934.398)

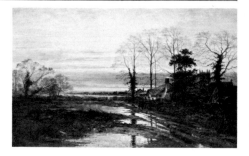

STEPPING STONES
1863

Oil on canvas
91·7 × 137·5 (36⅛ × 54⅛)
s(blc): *B. W. LEADER. 1863*
John E. Yates bequest (1934.407)

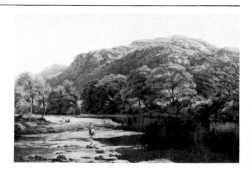

SHERE CHURCH, SURREY
1892

Oil on canvas
76·2 × 122·4 (30 × 48 $\frac{3}{16}$)
s(brc): *B. W. LEADER. 1892.*
John E. Yates bequest (1934.415)

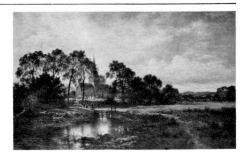

THE BREEZY MORN
1897

Oil on canvas
122·1 × 183·2 (48 $\frac{1}{16}$ × 72 $\frac{1}{8}$)
s(blc): *B. W. LEADER. 1897*
Herbert Morgan bequest (1935.481)

Alphonse Legros
See Foreign Schools catalogue

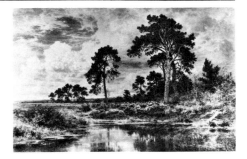

Frederic, Lord Leighton
1830–1896

THE LAST WATCH OF HERO
exh. 1887

Oil on canvas
160·3 × 91·7 (63 $\frac{1}{8}$ × 36 $\frac{1}{8}$)
Unsigned
Purchased (1887.9)
See also next item

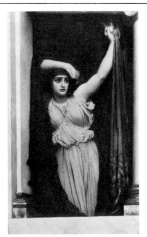

THE DEATH OF LEANDER
(Predella panel to THE LAST WATCH
OF HERO)

Oil on canvas
$33 \cdot 3 \times 76 \cdot 5$ $(13\frac{1}{8} \times 30\frac{1}{8})$
Unsigned
See previous item

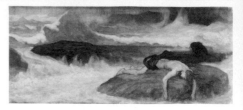

CAPTIVE ANDROMACHE
c.1888

Oil on canvas
197×407 $(77\frac{1}{2} \times 160\frac{1}{4})$
Unsigned
Purchased with the aid of friends
of the Gallery (1889.2)

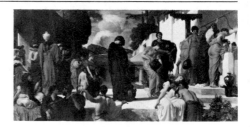

A ROMAN PEASANT GIRL

Oil on canvas
$42 \cdot 8 \times 32 \cdot 3$ $(16\frac{7}{8} \times 12\frac{11}{16})$
Unsigned
James Blair bequest (1917.245)

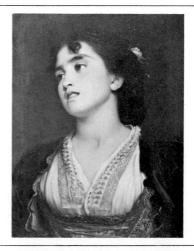

THE ISLE OF CHIOS
?1867

Oil on canvas
26·5 × 41·5 (10 $\frac{7}{16}$ × 16 $\frac{3}{8}$)
Unsigned
Mrs W. Heelis gift (1933.32)

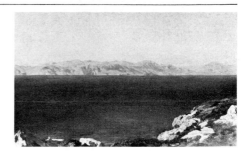

THE TEMPLE OF PHILAE
1868

Oil on canvas
18·7 × 29·3 (7 $\frac{3}{8}$ × 11 $\frac{1}{2}$)
Unsigned
John E. Yates bequest (1934.416)

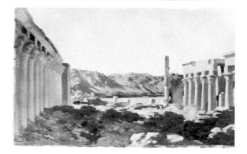

Henry Le Jeune
1819–1904

CHILDREN WITH A TOY BOAT
1865

Oil on panel
29·9 × 40·6 (11 $\frac{3}{4}$ × 16)
s(brc): *18 HLJ 65* (mon)
Sir Joseph Whitworth bequest
(1896.12)

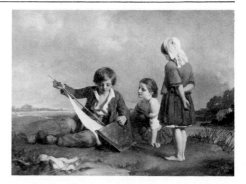

THE TIMID BATHER
1872

Oil on panel
30·6 × 25·4 ($12\frac{1}{16}$ × 10)
s(blc): *18 HLJ 72* (mon)
John E. Yates bequest (1934.395)

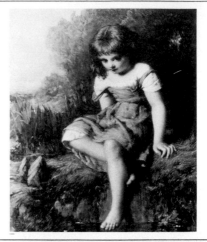

Sir Peter Lely
1618–1680

SIR JOHN COTTON AND HIS FAMILY
Sir John Cotton (1615–1689/90)
1660

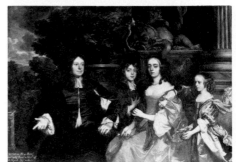

Oil on canvas
157·4 × 225·3 (62 × $88\frac{11}{16}$)
s(blc): *P. Lely. P./1660/S.ʳ Jnᵒ Cotton Kᵗ. & Barᵗ | Jane only Dauʳ. & Heirˢˢ of/ Ed. Hynde Esqʳ. & their/Son & Daughter.*
Purchased with the aid of the
N.A-C.F. (1966.344)

Attributed to Sir Peter Lely

LADY WHITMORE
Frances Brooke, wife of Sir Thomas
Whitmore, Bt.
*c.*1670–80

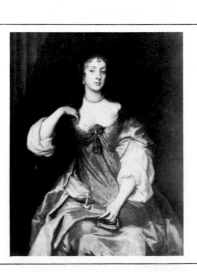

Oil on canvas
123 × 99·8 ($48\frac{7}{16}$ × $39\frac{1}{4}$)
Unsigned
Purchased (1901.4)

Follower of Sir Peter Lely

A LADY HOLDING A ROSE
c.1660–80

Oil on canvas
$113 \cdot 5 \times 92$ ($44\frac{11}{16} \times 35\frac{3}{4}$)
Unsigned
A. B. Ireland gift (1952.1)

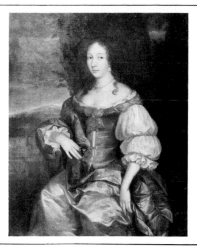

George Dunlop Leslie
1835–1921

THE LANGUAGE OF FLOWERS
1885

Oil on canvas
$112 \cdot 3 \times 145$ ($44\frac{3}{16} \times 57\frac{1}{16}$)
s(brc): *G. D. Leslie. 1885*
Purchased (1900.9)

John Linnell
1792–1882

LEITH HILL, SURREY
?1864

Oil on panel
34×46 ($13\frac{3}{8} \times 18\frac{1}{8}$)
s(brc): *J. Linnell/18...* (illegible)
Purchased (1900.21)

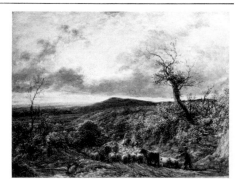

HAMPSTEAD HEATH
1855/6

Oil on canvas
$45 \cdot 8 \times 61 \cdot 1$ ($18 \times 24\frac{1}{16}$)
s(bl): *J. Linnell 1855* (? or 6)
James Blair bequest (1917.151)

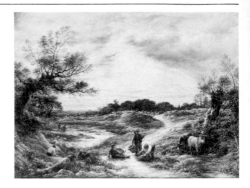

MID-DAY REST
1863

Oil on canvas
$71 \cdot 3 \times 99 \cdot 4$ ($28\frac{1}{8} \times 39\frac{1}{4}$)
s(brc): *J. Linnell 1863*
John E. Yates bequest (1934.418)

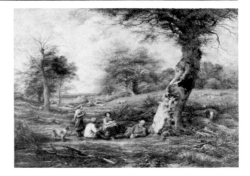

Henry Liverseege
1803–1832

THE GRAVE DIGGERS
(from Shakespeare's 'Hamlet')
1831

Oil on canvas
$28 \cdot 5 \times 22 \cdot 3$ ($11\frac{3}{16} \times 8\frac{3}{4}$)
Unsigned
Purchased (1903.3)

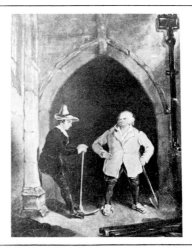

THE BETROTHED
1830

Oil on canvas
43·9 × 34·8 (17¼ × 13 11/16)
Unsigned
Purchased (1912.58)

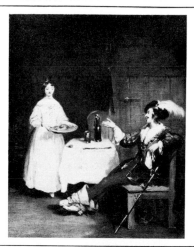

SIR PIERCIE SHAFTON AND MYSIE
HAPPER
(from Sir Walter Scott's 'The
Monastery')
?1831

Oil on canvas
42·1 × 34·8 (16 9/16 × 13 11/16)
Unsigned
Purchased (1912.59)

A TOUCH OF THE SPASMS

Oil on canvas
39·7 × 31·6 (15 5/8 × 12 7/16)
Unsigned
Purchased (1912.60)

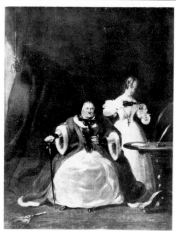

Robert Walker Macbeth
1848–1910

OSIER PEELING (ON THE CAM)
1875

Oil on canvas
$51 \cdot 6 \times 40 \cdot 8$ ($20\frac{5}{16} \times 16\frac{1}{16}$)
s(brc): *RM/75*
Mrs Annie Woodhouse bequest
(1940.79)

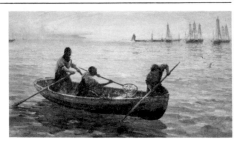

Hamilton Macallum
1841–1896

DIPPING FOR SPRATS
1893

Oil on canvas
$122 \cdot 5 \times 215 \cdot 5$ ($48\frac{1}{4} \times 84\frac{13}{16}$)
s(blc): *Hamilton Macallum/93* (in one
line)
Purchased (1899.3)

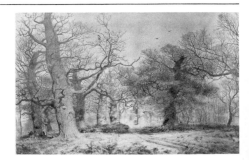

Andrew MacCallum
1821–1902

OAK TREES IN SHERWOOD FOREST
1877

Oil on canvas
$78 \cdot 5 \times 119$ ($30\frac{7}{8} \times 46\frac{7}{8}$)
s(brc): *Andrew MacCallum/1877*.
Transferred from the Horsfall
Museum (1918.418)

THE RIVER OF LIFE
1850

8 part polyptych
All oils on canvas
Gift of Mrs Thomas Worthington in
memory of her husband (1933.2)

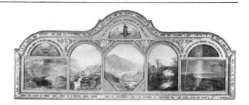

BIRTH

18.9×45 $(7\frac{7}{16} \times 17\frac{3}{4})$lunette
44×62 $(17\frac{5}{16} \times 24\frac{3}{8})$
Unsigned

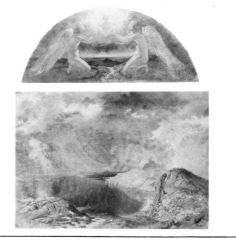

YOUTH

65.5×45 $(25\frac{3}{4} \times 17\frac{3}{4})$ arched top
Unsigned

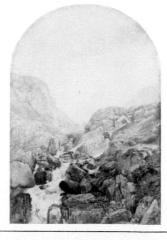

MANHOOD

22·6 × 48·2 (8⅞ × 19) lunette
66 × 58 (26 × 22⅞) octagon
s(blc): *A.M/1850* (mon)

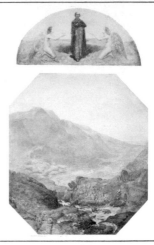

DECLINE

66 × 45·5 (26 × 17 15/16) arched top
Inscr (blc), illegible

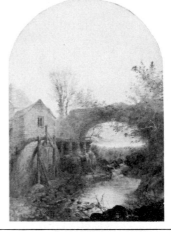

DEATH

19·1 × 45 (7½ × 17¾) lunette
44 × 61 (17 5/16 × 24)
s(blc): *A. MacCallum.*

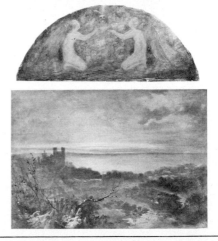

Daniel Maclise
1806–1870

A WINTER NIGHT'S TALE
*c.*1867

Oil on canvas
101·3 × 126·3 (39⅞ × 49¾)
Unsigned
Mrs E. A. Rylands bequest (1908.18)

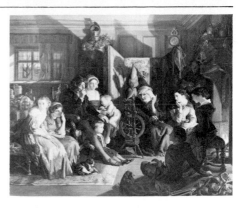

THE ORIGIN OF THE HARP
*c.*1842

Oil on canvas
110·4 × 85 (43½ × 33½)
Unsigned
James Gresham bequest (1917.269)

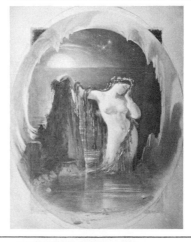

Sir Daniel Macnee
1806–1882

– 1800?

WILLIAM GIBB J.P. (1880–1873)
Manchester wine and spirit merchant
and City Councillor 1847–59

Oil on canvas
147·4 × 231·8 (58 × 91¼)
s(blc): *Daniel Macnee R.S.A./1871*
Manchester Royal Exchange gift
(1968.244)

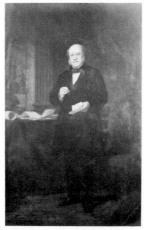

John MacWhirter
1839–1911

CONSTANTINOPLE AND THE GOLDEN
HORN FROM EYOUB
exh. 1889

Oil on canvas
154·2 × 245 (60 $\frac{11}{16}$ × 96 $\frac{1}{2}$)
s(brc): *MacW*
Frederick Smallman gift (1908.9)

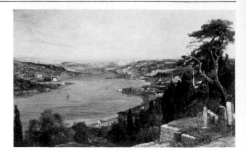

AUTUMN IN THE HIGHLANDS

Oil on canvas
102·7 × 150·8 (40 $\frac{1}{2}$ × 59 $\frac{3}{8}$)
s(blc): *Mac.W*
John E. Yates bequest (1934.408)

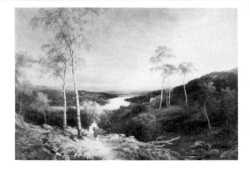

THE LADY OF THE WOODS
exh. 1876

Oil on canvas
152·7 × 105 (60 $\frac{1}{8}$ × 41 $\frac{3}{8}$)
s(blc): *MacWhirter*
Jesse Haworth bequest (1937.126)

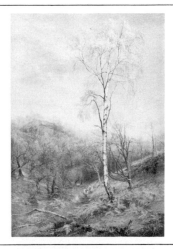

Henry Stacy Marks
1829–1898

SOUTH AFRICAN CROWNED CRANES
(Balearica regulorum regulorum –
Bennett; formerly called BIRDS)

Oil on canvas
63·5 × 122 (25 × 48)
s(brc): *H.S. MARKS.*
Anonymous gift (1920.1347)

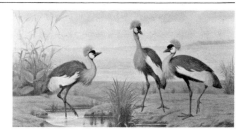

William Marlow
1740–1813

VIEW IN LYONS
(formerly called VIEW OF AVIGNON;
ITALIAN VIEW; AN ITALIAN TOWN)

Oil on canvas
50 × 65·5 (19 $\frac{11}{16}$ × 25 $\frac{3}{4}$)
s(brc): *W Marlow*
Purchased (1932.21)

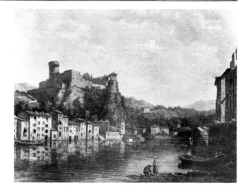

MATLOCK, DERBYSHIRE

Oil on canvas
38·3 × 53 (15 $\frac{1}{16}$ × 20 $\frac{7}{8}$)
Unsigned
Purchased (1938.263)

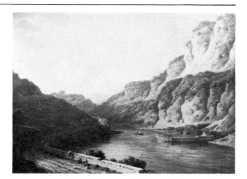

Robert Braithwaite Martineau
1826–1869

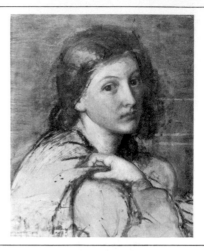

STUDY FOR A WOMAN OF SAN
GERMANO
(formerly called STUDY OF A WOMAN
HOLDING A BABY)
c.1864

Oil on canvas
44·7 × 37·4 ($17\frac{9}{16} \times 14\frac{3}{4}$)
Unsigned
Miss Helen Martineau bequest
(1951.9)

THE ARTIST'S WIFE IN A RED CAPE
née Maria Wheller m. 1865

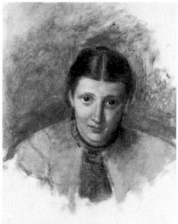

Oil on canvas
35·5 × 27·9 (14 × 11)
Unsigned
Miss Helen Martineau bequest
(1951.10)

George Hemming Mason
1818–1872

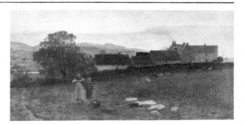

LANDSCAPE – DERBYSHIRE
exh. 1870

Oil on canvas
46 × 94·4 ($18\frac{1}{8} \times 37\frac{3}{16}$)
Unsigned
Purchased (1908.13)

ONLY A SHOWER
exh. 1869

Oil on canvas
$45 \cdot 9 \times 91 \cdot 7$ $(18\frac{1}{16} \times 36\frac{1}{16})$
Unsigned
Purchased (1911.18)

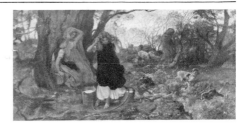

Henry Measham
1844–1922

THE ARTIST'S MOTHER
Mrs Mary Measham, aged 59
?1870

Oil on canvas
$61 \cdot 5 \times 51 \cdot 2$ $(24\frac{1}{4} \times 20\frac{1}{8})$
Unsigned
Richard Redfern gift (1907.4)

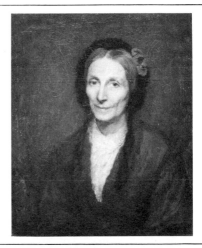

Sir John Everett Millais
1829–1896

A FLOOD
1870

Oil on canvas
$99 \cdot 3 \times 144 \cdot 9$ $(39\frac{1}{8} \times 57\frac{1}{16})$
s(brc): *18 JM 70* (mon)
Purchased (1891.7)

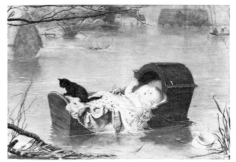

AUTUMN LEAVES
1856

Oil on canvas
104·3 × 74 (41$\frac{1}{16}$ × 29$\frac{1}{8}$)
s(brc): *18 JM 56* (mon)
Purchased (1892.4)

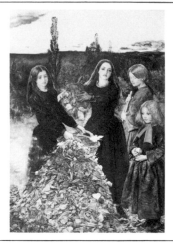

VICTORY O LORD
1871

Oil on canvas
194·7 × 141·3 (76$\frac{5}{8}$ × 55$\frac{5}{8}$)
s(brc): *18 JM 71* (mon)
Purchased (1894.1)

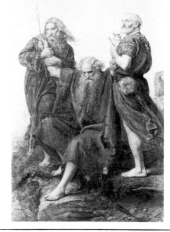

JAMES FRASER (1818–1885)
Bishop of Manchester 1870–1885
1880

Oil on canvas
128 × 93·6 (50$\frac{3}{8}$ × 36$\frac{13}{16}$)
s(brc): *18 JM 80* (mon)
Mrs Fraser bequest 1895 to the Town
Hall Committee; on permanent loan
to the City Art Gallery (M. 1441)

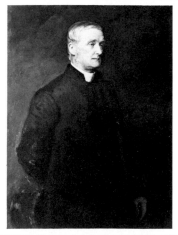

WINTER FUEL
1873

Oil on canvas
194·5 × 149·5 (76$\frac{9}{16}$ × 58$\frac{7}{8}$)
s(brc): *18 JM 73* (mon)
G. B. Worthington gift (1897.4)

STELLA
1868

Oil on canvas
112·7 × 92·1 (44$\frac{3}{8}$ × 36$\frac{1}{4}$)
s(brc): *18 M 68* (mon)
Purchased (1908.12)

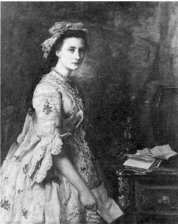

GLEN BIRNAM
1891

Oil on canvas
145·2 × 101·1 (57$\frac{1}{8}$ × 39$\frac{13}{16}$)
s(brc): *John E Millais/1891*
Mrs E. A. Rylands bequest (1908.15)

WANDERING THOUGHTS
(formerly called MRS CHARLES
FREEMAN)
c.1855

Oil on canvas
$35 \cdot 2 \times 24 \cdot 9$ $(13\frac{7}{8} \times 9\frac{13}{16})$
s(brc): *J E Millais.*
Purchased (1913.28)

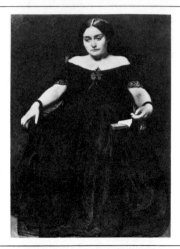

ONLY A LOCK OF HAIR
c.1857–8

Oil on panel
$35 \cdot 3 \times 25$ $(13\frac{7}{8} \times 9\frac{7}{8})$
s(blc): *M* (mon)
James Gresham bequest (1917.268)

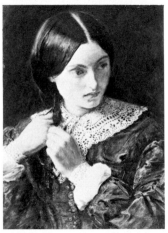

MRS LEOPOLD REISS
(of Broom House, Eccles; a founder of
the Hallé Orchestra)
1876

Oil on canvas
122×95 $(48 \times 37\frac{3}{8})$
s(blc): *18 JM 76* (mon)
Mrs Everard Hopkins gift (1932.1)

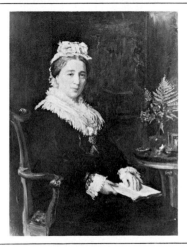

THE DEATH OF ROMEO AND JULIET
*c.*1848

Oil on millboard
16·1 × 26·9 (6$\frac{5}{16}$ × 10$\frac{5}{8}$)
s(brc): *JEM* (mon)
G. Beatson Blair bequest 1941
(1947.89)

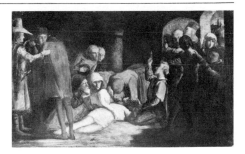

Albert Joseph Moore
1841–1893

AN IDYLL
1893

Oil on canvas
86·5 × 78·9 (34$\frac{1}{16}$ × 31$\frac{1}{16}$)
s(bl) with anthemion and dated: *93*
James Blair bequest (1917.223)

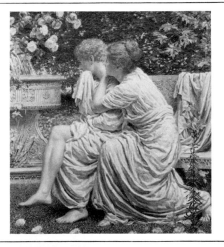

A FOOTPATH
(formerly called STUDY: STANDING
FIGURE OF A WOMAN)
1888

Oil on canvas
44·2 × 16·2 (17$\frac{3}{8}$ × 6$\frac{3}{8}$)
Unsigned
James Blair bequest (1917.227)

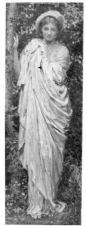

A GARLAND
1887–8

Oil on canvas
49·3 × 25·1 ($19\frac{7}{16} × 9\frac{7}{8}$)
s(br) with anthemion
James Gresham bequest (1917.255)

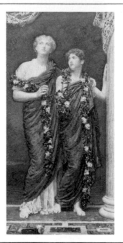

A READER
exh. 1877

Oil on canvas
87·2 × 32 ($34\frac{5}{16} × 12\frac{9}{16}$)
s(br) with anthemion
John E. Yates bequest (1934.413)

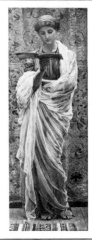

BIRDS OF THE AIR
exh. 1879

Oil on canvas
86·7 × 36·2 ($34\frac{1}{8} × 14\frac{1}{4}$)
s(brc) with anthemion
John E. Yates bequest (1934.414)

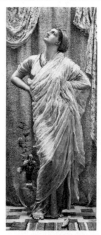

Henry Moore
1831–1895

MOUNT'S BAY: EARLY MORNING –
SUMMER
(Cornwall)
1886

Oil on canvas
122·2 × 213·5 (48⅛ × 84⅛)
s(brc): *H. Moore. 1886.*
Purchased (1886.7)

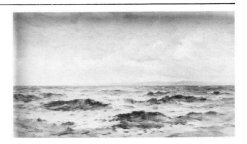

(formerly attributed to George
Richmond)

CATTLE FORDING A STREAM

Oil on canvas
71·5 × 111·8 (28⅛ × 44)
s(brc): *hm/1862* (mon)
Transferred from the Horsfall
Museum (1918.419)

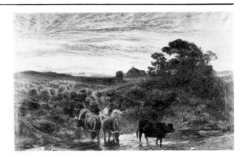

ARRAN (ACROSS KILBRANNAN
SOUND)
1894

Oil on canvas
30·5 × 54·7 (12 × 21$\frac{9}{16}$)
s(brc): *H. Moore. 1894.*
Mrs Annie Woodhouse bequest
(1940.78)

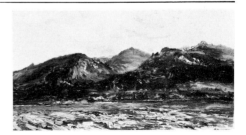

George Morland
1763–1804

A FARRIER'S SHOP
(also called THE FARRIER'S FORGE)
1793

Oil on canvas
71·1 × 91·5 (28 × 36)
s(bl): *G. Morland./1793*
Transferred from the Royal
Manchester Institution (1882.1)

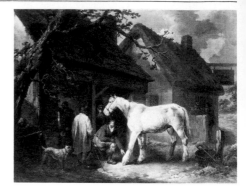

George Morland
See also Julius Caesar Ibbetson

Henry Robert Morland
1716–1797

(formerly attributed to Johann
Zoffany)

AN OFFICER OF THE FOOT GUARDS
*c.*1760

Oil on canvas
43·7 × 35·1 ($17\frac{3}{16} \times 13\frac{13}{16}$)
Unsigned
Purchased (1928.90)

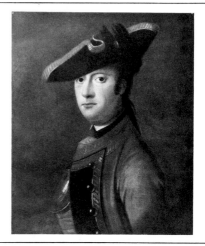

Philip Richard Morris
1836–1902

THE NANCY LEE OF GREAT
YARMOUTH

Oil on canvas
91·9 × 153·2 ($36\frac{3}{16} \times 60\frac{5}{16}$)
s(blc): *Phil Morris*
Purchased (1883.27)

William Bright Morris
1844–1915

NEAR THE VILLAGE OF CREÇY,
FRANCE

Oil on canvas
86·4 × 127·6 (34 × 50¼)
s(blc): *W. BRIGHT MORRIS*
Purchased (1890.62)

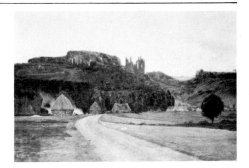

SPANISH BEGGARS

Oil on canvas
120·8 × 96·5 (47 $\frac{9}{16}$ × 38)
Unsigned
Mrs Isaac Morris gift (1898.2)

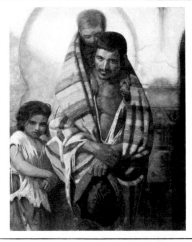

William Jabez Muckley
1837–1905

ROSES
1883

Oil on canvas
61 × 50·8 (24 × 20)
s(bl): *W. J. Muckley. 1883* (mon)
James Chadwick gift (1888.2)

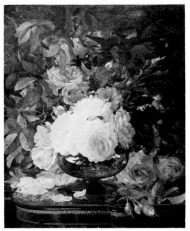

GRAPES
1875

Oil on canvas
$40 \cdot 7 \times 49 \cdot 7$ $(16\frac{1}{16} \times 19\frac{9}{16})$
s(brc): *Muckley. 1875*
Mrs C. S. Garnett bequest (1936.120)

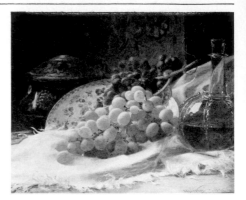

William James Müller
1812–1845

A ROCK TOMB, LYCIA
c.1843–4

Oil on canvas
$41 \cdot 4 \times 53 \cdot 4$ $(16\frac{5}{16} \times 21)$
s(br): *W Muller*
Purchased (1896.3)

AN ENCAMPMENT IN THE DESERT
?1844–5

Oil on canvas
$101 \cdot 7 \times 210 \cdot 3$ $(40 \times 82\frac{3}{4})$
Unsigned
Purchased (1897.3)

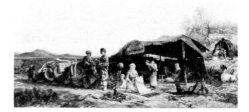

BURIAL GROUND, SMYRNA
(also called TURKISH CEMETERY AT
SMYRNA)
exh. 1845

Oil on canvas
$32 \cdot 7 \times 51 \cdot 1$ ($12\frac{7}{8} \times 20\frac{1}{8}$)
Unsigned
Purchased (1907.8)

THE APPROACHING STORM
(perhaps A COUNTRY LANE AT
GILLINGHAM)
1845

Oil on panel
$39 \cdot 8 \times 28 \cdot 2$ ($15\frac{11}{16} \times 11\frac{1}{8}$)
Unsigned
James Blair bequest (1917.162)

HAULING TIMBER

Oil on canvas, arched top
$78 \cdot 4 \times 126 \cdot 8$ ($30\frac{7}{8} \times 49\frac{7}{8}$)
Unsigned
Gift of the family of John Cooke
Hilton (1927.26)

LANDSCAPE: COTTAGE, TREES, A
STREAM AND DISTANT HILLS
1837

Oil on panel
67×99 ($26\frac{3}{8} \times 39$)
s(bl): *W. Müller./1837.*
Mr and Mrs G. Sanville gift (1964.253)

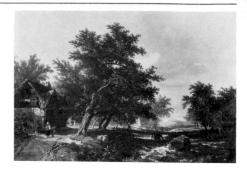

William Mulready
1786–1863

THE CARELESS MESSENGER
DETECTED
(formerly called THE CARELESS
NURSE)
1821

Oil on canvas
$26 \times 20 \cdot 7$ ($10\frac{1}{4} \times 8\frac{1}{8}$)
s(blc): *W. Mulready 1821*
Lloyd Roberts bequest (1920.524)

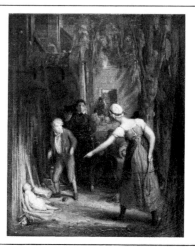

Sir David Murray
1849–1933

BRITANNIA'S ANCHOR
(on the River Dart)
1887

Oil on canvas
$101 \cdot 7 \times 154$ ($40\frac{1}{16} \times 60\frac{5}{8}$)
s(blc): *David Murray. 87.*
Purchased (1888.5)

OLD SHOREHAM
1898

Oil on canvas
121·3 × 182·4 (47¾ × 71¹³⁄₁₆)
s(blc): *David Murray. 98.*
Gift of the Executors of the artist
(1939.228)

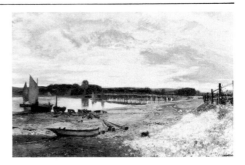

After Daniel Mytens
*c.*1590–before 1648
(formerly attributed to George
Jamesone)

JAMES HAMILTON, 2ND MARQUESS OF
HAMILTON (1589–1625)
*c.*1620–25

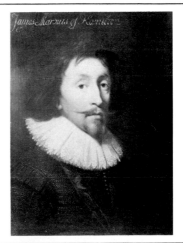

Oil on panel
39·6 × 30·7 (15⁷⁄₁₆ × 12¹⁄₁₆)
Inscr(tlc): *James Marquis of
Hamilton*
G. Beatson Blair bequest 1941
(1947.84)

Alexander Nasmyth
1758–1840

RIVER LANDSCAPE WITH RUINED
CASTLE

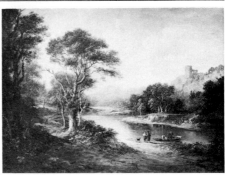

Oil on canvas
45·9 × 61 (18¹⁄₁₆ × 24)
Unsigned
Gift of the daughters of the Rev.
William Gaskell (1884.7)

VIEW OF THE PONTE MOLLE, ON THE
SYLVAN SIDE OF ROME
?1810

Oil on canvas
$81 \cdot 9 \times 116$ ($32\frac{1}{4} \times 45\frac{5}{8}$)
s(blc): *AN*
Purchased (1902.12)

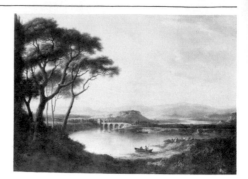

Patrick Nasmyth
1787–1831

NEAR DULWICH
1826

Oil on panel
$24 \cdot 7 \times 39 \cdot 3$ ($9\frac{3}{4} \times 15\frac{1}{2}$)
s(brc): *Pat^k. Nasmyth/1826*
James Gresham bequest (1917.263)

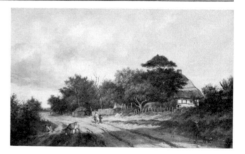

LANDSCAPE WITH HAYSTACKS
1827

Oil on panel
$29 \cdot 6 \times 40 \cdot 7$ ($11\frac{5}{8} \times 16$)
s(brc): *Pat^k. Nasmyth/1827.*
John E. Yates bequest (1934.393)

WOODED LANDSCAPE WITH DISTANT VIEW

Oil on panel
$23 \cdot 4 \times 31 \cdot 6$ ($9\frac{3}{16} \times 12\frac{7}{16}$)
s(brc): *P Nasm*(yth)/*182*... (illegible)
Gift of the Executors of J. R. Oliver
(1934.436)

LANDSCAPE WITH SHEEP AND SHEPHERD

Oil on panel
$28 \cdot 7 \times 41 \cdot 9$ ($11\frac{5}{16} \times 16\frac{1}{2}$)
Unsigned
G. Beatson Blair bequest 1941
(1947.90)

SONNING ON THE THAMES

Oil on panel
$31 \cdot 6 \times 48 \cdot 7$ ($12\frac{7}{16} \times 19\frac{3}{16}$)
Unsigned
Gift of M. K. Burrows in memory of
Lady Gaskell, widow of Sir Holbrook
Gaskell (1953.439)

John William North
1842–1924

THE FLOWER AND THE LEAF

Oil on canvas
$66 \cdot 5 \times 99 \cdot 8$ ($26\frac{3}{16} \times 39\frac{5}{16}$)
Unsigned
Purchased (1901.2)

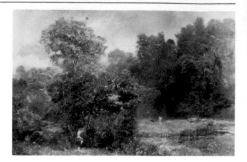

SPRINGTIME

Oil on canvas
$66 \cdot 2 \times 98 \cdot 9$ ($26\frac{1}{16} \times 38\frac{15}{16}$)
Unsigned
Purchased (1908.10)

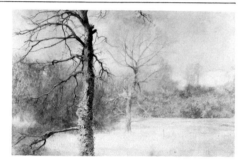

James Northcote
1746–1831

OTHELLO, THE MOOR OF VENICE
(also called A MOOR)
1826

Oil on canvas
$76 \cdot 2 \times 63 \cdot 5$ (30×25)
s(r above shoulder): *J.^s Northcote/*
pinx.^t/1826
Transferred from the Royal
Manchester Institution (1882.2)

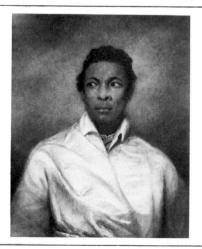

John Wright Oakes
1820–1887

GLEN MUICK, ABERDEENSHIRE
1872

Oil on canvas
122·8 × 168·7 (48$\frac{5}{16}$ × 60$\frac{7}{16}$)
s(brc): *J W Oakes/72* (mon)
Purchased (1887.14)

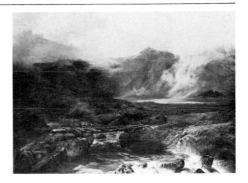

Attributed to William Oliver
1805–1853

AT THE OPERA

Oil on canvas
45·6 × 35·9 (17$\frac{15}{16}$ × 14$\frac{1}{8}$)
Unsigned
Frank R. Craston bequest (1939.145)

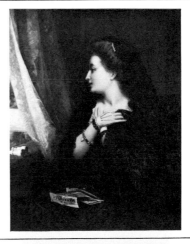

William Oliver
active 1867–1897

THE DUENNA
1877

Oil on canvas
50·7 × 40·6 (19$\frac{15}{16}$ × 16)
s(blc): *W. Oliver. 1877*
James Blair bequest (1917.190)

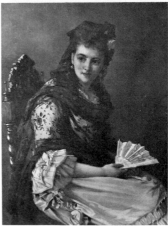

Sir William Quiller Orchardson
1832–1910

HER IDOL
c.1868–70

Oil on canvas
75·2 × 95·9 ($29\frac{5}{8}$ × $37\frac{3}{4}$)
s(bl): *W Q Orchardson.*
Purchased (1910.39)

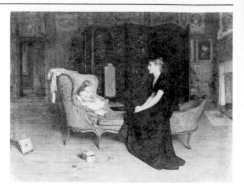

MRS JOHN PETTIE
née Elizabeth Ann Bossom; m. John
Pettie, R.A., 1865; d.1916
1865

Oil on canvas
99·9 × 79·5 ($39\frac{3}{8}$ × $31\frac{5}{16}$)
Unsigned
Purchased (1926.12)

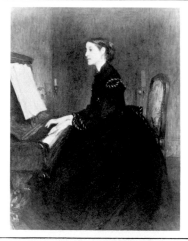

MRS ROBERT MACKAY
c.1868

Oil on canvas
91·4 × 71·3 (36 × $28\frac{1}{16}$)
Unsigned
Dr Thomas Fentem gift (1935.18)

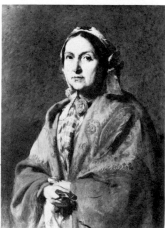

Walter William Ouless
1848–1933

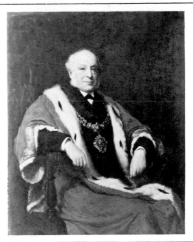

ALDERMAN PHILIP GOLDSCHMIDT
(1812–1889)
Mayor of Manchester 1883–4,
1885–6
1887

Oil on canvas
127·7 × 102·7 (50¼ × 40 7/16)
s(blc): *W. W. Ouless/1887*
Gift of fellow citizens of the sitter
(1888.8)

S. C. Parlby

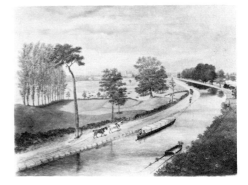

THE BRIDGEWATER CANAL FROM
DR. WHITE'S BRIDGE, LOOKING
TOWARDS MANCHESTER
1857

Oil on canvas
34·9 × 46 (13¾ × 18⅛)
Unsigned
Purchased (1928.76)

Joseph Parry
1744–1826

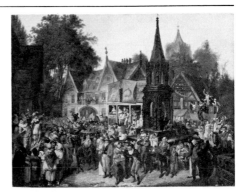

THE VILLAGE FAIR
1819

Oil on panel
26·9 × 34·9 (10 9/16 × 13¾)
s(br): *Jo: Parry/1819*
Purchased (1927.10)

ECCLES WAKES

Oil on panel
30·3 × 30·7 (11$\frac{15}{16}$ × 12$\frac{1}{16}$)
Unsigned
Purchased (1927.11)

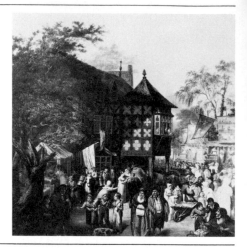

ECCLES WAKES: RACING FOR THE
SMOCK
?1808

Oil on canvas
71·7 × 91·8 (28$\frac{1}{4}$ × 36$\frac{1}{8}$)
s(bl): *Jos. Parry/Manch/(1)808* (?)
Purchased (1927.12)

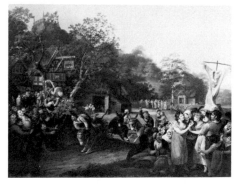

ECCLES WAKES: ALE-HOUSE INTERIOR

Oil on canvas
71·3 × 71·3 (28$\frac{1}{16}$ × 28$\frac{1}{16}$)
Unsigned
Purchased (1927.13)

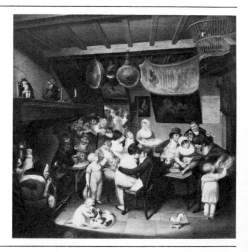

John H. E. Partington
1843–1899

WILLIAM ALFRED TURNER (1839–1886)
County Magistrate and art collector
1886

Oil on canvas
$127\cdot2\times101\cdot7$ $(50\frac{1}{16}\times40\frac{1}{16})$
s(blc): *J. H. E. Partington/1886–*
Purchased (1886.4)

DR JOSEPH GOUGE GREENWOOD
(1821–1894)
Principal of Owen's College 1857–
89 and Vice-Chancellor of the
Victoria University, Manchester
1880–86
1883

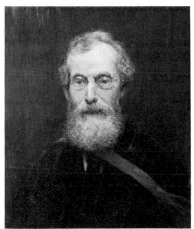

Oil on canvas
$60\cdot9\times51$ $(24\times20\frac{1}{16})$
s(blc): *J. H. E. Partington./1883*
The Misses Greenwood gift (1912.69)

After Robert Peake the Elder
active 1576–?d 1626

A PROCESSION OF QUEEN
ELIZABETH I

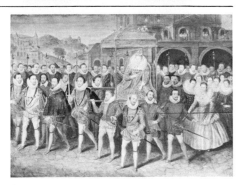

Oil on panel
$38\cdot4\times53\cdot3$ $(15\frac{1}{8}\times21)$
Unsigned
G. Beatson Blair bequest 1941
(1947.145)

Arthur Douglas Peppercorn
1847–?1926

CORN RICKS
exh. 1898

Oil on canvas
$40 \times 66 \cdot 3$ $(15\frac{3}{4} \times 26\frac{1}{8})$
s(brc): *Peppercorn*
Purchased (1898.11)

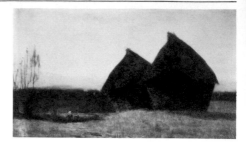

THE YACHT

Oil on canvas
$62 \cdot 2 \times 92 \cdot 6$ $(24\frac{1}{2} \times 36\frac{7}{16})$
s(brc): *Peppercorn.*
Frederick Todd gift (1913.1)

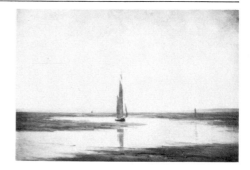

PATH BY THE RIVER RIPLEY

Oil on canvas
$39 \cdot 5 \times 67 \cdot 4$ $(15\frac{9}{16} \times 26\frac{9}{16})$
s(blc): *Peppercorn*
Frederick Todd gift (1925.60)

SEASCAPE

Oil on canvas
45·8 × 81·3 (18 × 32)
s(blc): *Peppercorn*.
Frederick Todd gift (1925.61)

William Percy
1820–1903

EDWIN WAUGH (1817–1890)
Lancashire dialect poet
1882

Oil on canvas
91·4 × 71·2 (36 × 28 $\frac{1}{16}$)
s(trc): *W. Percy/1882*
T. R. Wilkinson gift (1884.49)

SELF-PORTRAIT
1878

Oil on canvas
51·2 × 41 (20 $\frac{1}{8}$ × 16 $\frac{1}{8}$)
s(tlc): *W Percy 1878*
J. W. Bentley gift (1904.18)

Charles Edward Perugini
1840–1918

GIRL READING
1878

Oil on canvas
97·9 × 73 (38 $\frac{9}{16}$ × 28 $\frac{3}{4}$)
s(blc): *C P March 1878* (initials in mon)
James Blair bequest (1917.237)

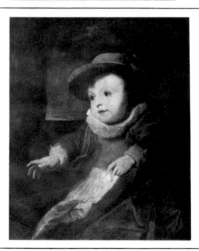

Rev. Mathew William Peters
1742–1814

A CHILD

Oil on canvas
61·3 × 51·5 (24 $\frac{1}{8}$ × 20 $\frac{1}{4}$)
Unsigned
G. Beatson Blair bequest 1941
(1947.133)

Abraham Pether
1756–1812

THIRLMERE, CUMBERLAND
?1801

Oil on canvas
61·4 × 92 (24 $\frac{3}{16}$ × 36 $\frac{1}{4}$)
Unsigned
Edward Rogerson gift (1909.11)

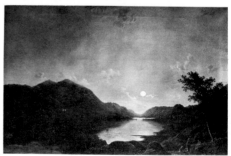

ST ALBAN'S ABBEY, HERTFORDSHIRE
1796

Oil on canvas
38×48 ($14\frac{15}{16} \times 18\frac{7}{8}$)
s(brc): *A Pether./1796*
G. Beatson Blair bequest 1941
(1947.73)

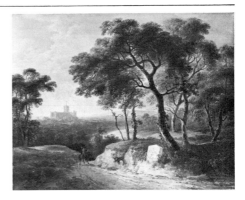

John Pettie
1839–1893

THE DUKE OF MONMOUTH'S
INTERVIEW WITH JAMES II
exh. 1882

Oil on canvas
$93 \cdot 4 \times 130 \cdot 5$ ($36\frac{3}{4} \times 51\frac{3}{8}$)
s(brc): *J. Pettie*
Purchased (1899.2)

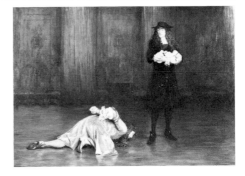

A SONG WITHOUT WORDS

Oil on canvas
$60 \cdot 8 \times 43 \cdot 2$ ($23\frac{15}{16} \times 17$)
s(blc): *J Pettie–*
Purchased (1904.9)

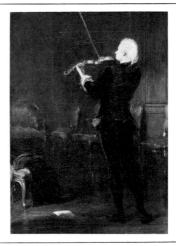

Frederick Richard Pickersgill
1820–1900

SAMSON BETRAYED
1850

Oil on canvas
243·8 × 306 (96 × 120½)
s(brc): *F. R. Pickersgill. R.A. 1850*
Transferred from the Royal
Manchester Institution (1882.19)

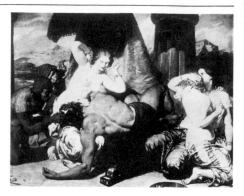

MERCURY INSTRUCTING THE NYMPHS
IN DANCING
(formerly called A DANCE OF THE
MUSES)
1848

Oil on panel
58·3 × 91·7 (22$\frac{15}{16}$ × 36$\frac{1}{8}$)
s(blc): *F. R. PICKERSGILL. ARA.
1848*
Sir Joseph Whitworth bequest
(1896.8)

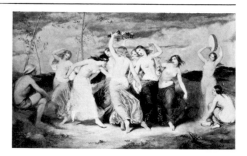

A LITTLE GONDELAY

Oil on millboard
48·3 × 61·1 (19 × 24$\frac{1}{16}$)
Unsigned
Miss Sophia Armitt bequest (1909.16)

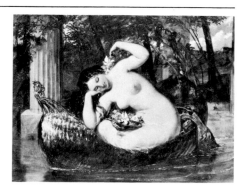

Paul Falconer Poole
1807–1879

THE GOTHS IN ITALY
*c.*1851–3

Oil on canvas
142 × 209·5 (55⅞ × 82½)
s(brc): *P F· Poole 1853*
Purchased (1891.9)

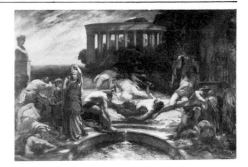

MOTHER AND CHILD
1849

Oil on canvas
50·9 × 41·1 (20 1/16 × 16 3/16)
s(b centre): *PP 49*
Sir Joseph Whitworth bequest
(1896.7)

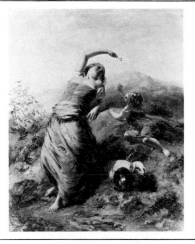

Sir Edward John Poynter
1836–1919

THE IDES OF MARCH
exh. 1883

Oil on canvas
153 × 112·6 (60¼ × 44 5/16)
Unsigned
Purchased (1883.18)

THE VISION OF ENDYMION
1902

Oil on canvas
50·8 × 38·1 (20 × 15)
s(br): *EJP/1902* (mon)
Purchased (1904.2)

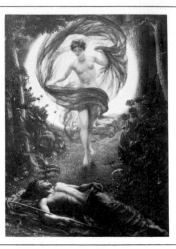

DIANA AND ENDYMION
1901

Oil on canvas
77·5 × 57·1 (30½ × 22½)
s(brc): *19 EJP 01* (mon)
James Gresham bequest (1917.254)

Norman Prescott Davies
See Davies

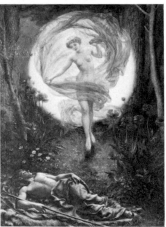

Valentine Cameron Prinsep
1838–1904

AT THE GOLDEN GATE
exh. 1882

Oil on canvas
137·5 × 95·8 (54⅛ × 37 11/16)
Unsigned
W. A. Turner gift (1883.22)

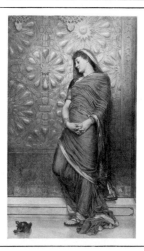

CINDERELLA
exh. 1899

Oil on canvas
149·6 × 113·1 ($58\frac{7}{8}$ × $44\frac{1}{2}$)
Unsigned
Mrs E. A. Rylands bequest (1908.**17**)

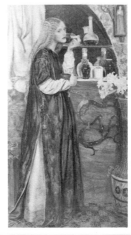

THE QUEEN WAS IN THE PARLOUR,
EATING BREAD AND HONEY
exh. 1860

Oil on panel
59·6 × 33 ($23\frac{1}{2}$ × 13)
s(brc): *VCP* (mon)
Purchased (1938.487)

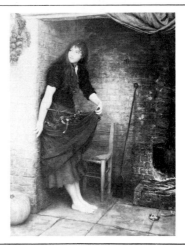

Edward Pritchett
active 1828–1864

ST MARK'S, VENICE

Oil on canvas
35·7 × 30·8 ($14\frac{1}{16}$ × $12\frac{1}{8}$)
s(brc): *E Pritchett*
Purchased (1902.5)

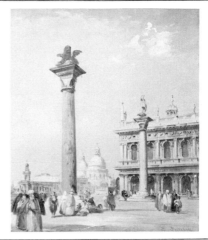

James Baker Pyne
1800–1870

BOPPARD ON THE RHINE
1855

Oil on canvas
$41\cdot4\times51\cdot3$ ($16\frac{5}{16}\times20\frac{3}{16}$)
s(b centre): *J B PYNE 1855*
James Blair bequest (1917.159)

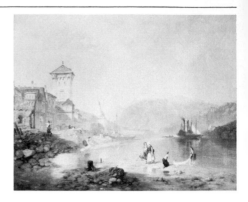

James Baker Pyne
See also Thomas Sidney Cooper

Attributed to Sir Henry Raeburn
1756–1823

ALEXANDER GORDON, 4TH DUKE OF
GORDON (1743–1827)

Oil on canvas
$76\cdot5\times63\cdot6$ ($30\frac{1}{8}\times25$)
Unsigned
Purchased (1902.10)

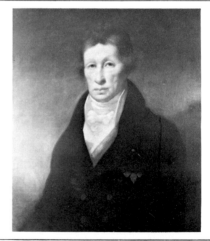

MRS SHAFTO CLARKE AND HER
DAUGHTER
*c.*1785–95

Oil on canvas
$126\times100\cdot6$ ($49\frac{5}{8}\times39\frac{5}{8}$)
Unsigned
James Blair bequest (1917.173)

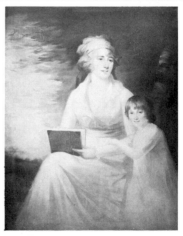

ALEXANDER CAMPBELL OF HILLYARDS
(1768–1817)
c.1810

Oil on canvas
75·5 × 62·2 (29¾ × 24½)
Unsigned
James Blair bequest (1917.174)

Allan Ramsay
MRS DELANY (1904.1)
Now attributed to French School
(Foreign Schools catalogue)

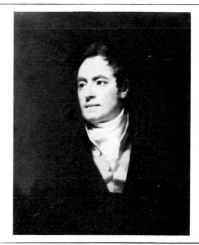

Alfred Rankley
1819–1872

MUSIC HATH CHARMS

Oil on canvas
44·1 × 56·2 (17⅜ × 22⅛)
s(blc): *A Rankley.*
Miss Florence Harrison bequest
(1971.39)

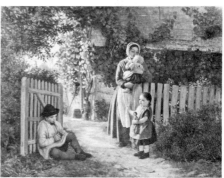

James Rawson
active 1855–63

APPLES, GRAPES AND STRAWBERRIES
1863

Oil on panel
$19 \times 26 \cdot 7$ ($7\frac{1}{2} \times 10\frac{1}{2}$)
s(brc): *18 JR 63* (mon)
Lloyd Roberts bequest (1920.544)

Sir George Reid
1841–1913

THE REV. ALEXANDER MCLAREN
(1826–1908)
Pastor at the Union Chapel,
Manchester (1858–1908)

Oil on canvas
$123 \cdot 7 \times 80 \cdot 4$ ($48\frac{11}{16} \times 31\frac{5}{8}$)
s(trc): *R*
Gift of friends in commemoration of
50 years' ministerial service (1896.28)

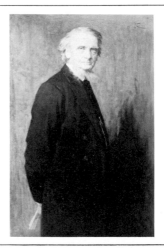

ALDERMAN SIR JAMES HOY (1837–1908)
Lord Mayor of Manchester 1902
1902–3

Oil on canvas
$124 \times 95 \cdot 2$ ($48\frac{13}{16} \times 37\frac{1}{2}$)
s(trc): *R·*
Sir James Hoy gift (1903.16)

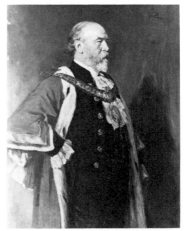

JAMES MOORHOUSE (1826–1915)
Bishop of Manchester 1886–1903

Oil on canvas
124 × 102·7 (48$\frac{13}{16}$ × 40$\frac{7}{16}$)
s(trc): *R*
Miss Edith E. Sale gift (1924.35)

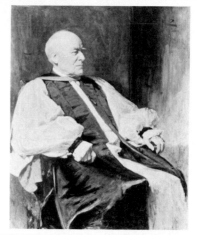

Sir Joshua Reynolds
1723–1792

ADMIRAL LORD HOOD (1724–1816)
(as Rear Admiral)
*c.*1783

Oil on canvas
127·2 × 100·9 (50$\frac{1}{16}$ × 39$\frac{3}{4}$)
Unsigned
Purchased (1898.3)

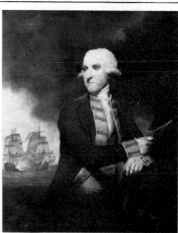

LADY ANSTRUTHER
Maria Brice, d.1811, wife of Sir John
Anstruther, Bart.
*c.*1763

Oil on canvas
76·5 × 62·6 (30$\frac{1}{8}$ × 24$\frac{5}{8}$)
Unsigned
Purchased (1898.4)

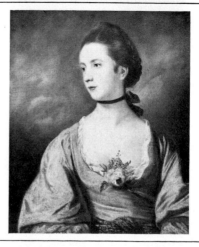

Attributed to Jonathan Richardson
1665–1745

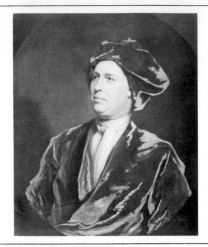

A GENTLEMAN IN RED VELVET
(in costume of 1740–70)

Oil on canvas
$75 \cdot 4 \times 63$ ($29\frac{11}{16} \times 24\frac{13}{16}$)
Unsigned
Farewell gift of the Royal Manchester
Institution (1973.291)

George Richmond
See Henry Moore

Sir William Blake Richmond
1842–1921

NEAR VIA REGGIO, WHERE SHELLEY'S
BODY WAS FOUND
exh. 1876

Oil on canvas
$91 \cdot 5 \times 228 \cdot 8$ ($36 \times 90\frac{1}{16}$)
Unsigned
Gift of the sons of the artist (1924.63)

Briton Rivière
1840–1920

THE LAST OF THE GARRISON
1875

Oil on canvas
$105 \times 152 \cdot 8$ ($41\frac{5}{16} \times 60\frac{1}{8}$)
s(blc): *Briton Riviere 1875*
Purchased (1898.7)

'IN MANUS TUAS DOMINE'
1879

Oil on canvas
147·7 × 217·6 (58$\frac{1}{8}$ × 85$\frac{11}{16}$)
s(brc): *B.RIVIERE/1879*
Gift of the sons of Abraham Haworth
in memory of their father (1902.14)

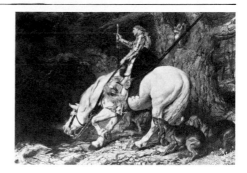

DEAD HECTOR
(also called HECTOR LYING DEAD)
1892

Oil on canvas
76·8 × 122·7 (30$\frac{1}{4}$ × 48$\frac{5}{16}$)
s(brc): *BR 1892* (mon)
James Gresham bequest (1917.259)

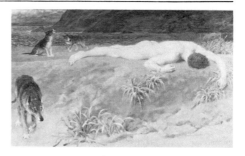

CALVES IN A MEADOW
1864
Oil on millboard
20·1 × 25·4 (7$\frac{7}{8}$ × 10)
s(blc): *BR/1864*
Lloyd Roberts bequest (1920.547)

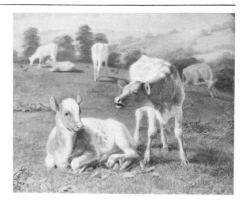

DANIEL'S ANSWER TO THE KING
1890

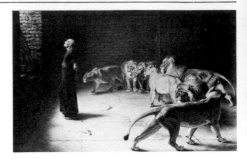

Oil on canvas
120·5 × 187·9 (47$\frac{7}{16}$ × 74)
s(blc): *18 BR 90* (mon)
Jesse Haworth bequest (1937.123)

HIS ONLY FRIEND

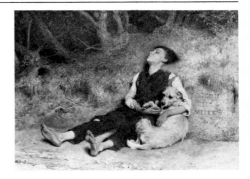

Oil on canvas
69·4 × 95·1 (27$\frac{5}{16}$ × 37$\frac{7}{16}$)
s(blc): *Briton Rivière 1871*
Jesse Haworth bequest (1937.124)

David Roberts
1796–1864

THE LADY CHAPEL, CHURCH OF
ST. PIERRE, CAEN
1832

Oil on panel
48·7 × 39·7 (19$\frac{3}{16}$ × 15$\frac{5}{8}$)
Unsigned
Purchased (1904.8)

THE HIGH ALTAR OF THE CHURCH OF
SS GIOVANNI E PAOLO AT VENICE
1858

Oil on canvas
142·3 × 107·5 (56 × 42⅛)
s(brc): *David Roberts R.A. 1858*
Lloyd Roberts bequest (1920.537)

John Ewart Robertson
1820–1879

JAMES HATTON (1795–1878)
Salford iron trader; an Hereditary
Governor of the Royal Manchester
Institution 1838–after 1846

Oil on canvas
91·7 × 71·8 (36⅛ × 28¼)
Unsigned
Mrs Elizabeth Hatton Wood gift
(1908.24)

Annie Louisa Robinson
See Annie Louisa Swynnerton

William Thomas Roden
1817–1892

JOHN HENRY NEWMAN (1801–1890)
(later Cardinal)
after 1874

Oil on canvas
127 × 101·3 (50 × 39⅞)
Unsigned
R. H. Wood bequest (1908.25)

George Romney
1734–1802

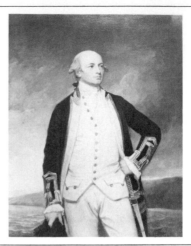

CAPTAIN WILLIAM PEERE WILLIAMS
(1742–1832)
(later Rear-Admiral Williams-
Freeman)
1782–3

Oil on canvas
126·9 × 101 (50 × 39¾)
Unsigned
Purchased (1950.297)

George Romney
See also English School c.1740–50;
Joseph Wright of Derby

Michael Angelo Rooker
1743–1801

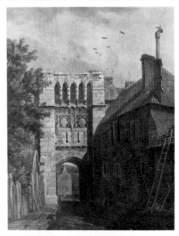

WESTGATE, WINCHESTER
exh. 1779

Oil on canvas
50·8 × 40 (20 × 15¾)
s(bl): *M Rooker A/Pinx!* (M R in mon)
inscr (bl): *West-gate/Winchester*
F. J. Nettlefold gift (1948.224)

Dante Gabriel Rossetti
1828–1882

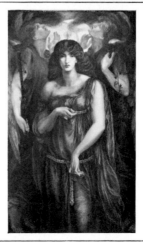

ASTARTE SYRIACA
1877

Oil on canvas
185 × 109 (72 13/16 × 42 15/16)
s(blc): *D.G. Rossetti. 1877.*
Purchased (1891.5)

THE BOWER MEADOW
1850–1872

Oil on canvas
86·3 × 68 (34 × 26¾)
s(blc): *D G Rossetti/1872*
Purchased (1909.15)

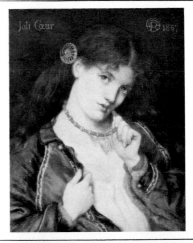

JOLI COEUR
1867

Oil on panel
38·1 × 30·2 (15 × 11⅞)
s(trc): *DGR 1867* (mon)
Miss A. E. F. Horniman bequest
(1937.746)

Paul Sandby
1725–1809

CARNARVON CASTLE BY MOONLIGHT,
IN THE FIRE OF 1791

Oil on canvas
54 × 64·4 (21¼ × 25⅜)
Unsigned
W. A. Sandby bequest (1905.7)

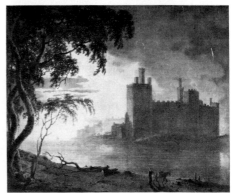

Frederick Sandys
1829–1904

VIVIEN
1863

Oil on canvas
$64 \times 52 \cdot 5$ ($25\frac{3}{16} \times 20\frac{11}{16}$)
Unsigned. Inscr(blc): *1863*
Purchased (1925.70)

James Sant
1820–1916

A THORN AMIDST THE ROSES/
exh. 1887

Oil on canvas
$111 \cdot 8 \times 86 \cdot 5$ ($44 \times 34\frac{1}{16}$)
s(blc): *JS* (mon)
Purchased (1887.12)

Reuben T. W. Sayers
1815–1888

THE WATER LILY
exh. 1851

Oil on canvas
$79 \times 48 \cdot 2$ ($31\frac{1}{8} \times 19$)
Formerly inscr: *Reuben Sayers*
Pinxit | 1 St Peters Square |
Hammersmith. | London.
Transferred from the Royal
Manchester Institution (1882.24)

William Shayer
1788–1879

LANDSCAPE WITH CATTLE BY A
STREAM
(also called CHANGING PASTURES)

Oil on canvas
71·4 × 91·8 (28⅛ × 36⅛)
s(blc): *Wm. Shayer Senr*
James Gresham bequest (1917.251)

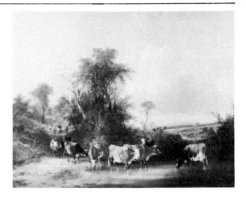

Sir Martin Archer Shee
1769–1850

MAJOR GENERAL SIR BARRY CLOSE,
BART. (1756–1813)
?after 1811

Oil on canvas
127 × 101·9 (50 × 40⅛)
Unsigned
Purchased (1955.25)

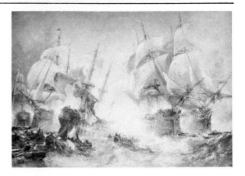

George Sheffield
1839–1892

A HUNDRED YEARS AGO
1890

Oil on canvas
117·3 × 166 (46 3/16 × 65⅜)
s(blc): *G. Sheffield/1890*
Purchased (1890.90)

Juliana C. Shepherd
active 1858–70, d.1898

THOUGHTS OF THE FUTURE

Oil on canvas
$40 \cdot 2 \times 30 \cdot 4$ ($15\frac{13}{16} \times 11\frac{15}{16}$)
Unsigned
Bequest of the artist (1899.1)

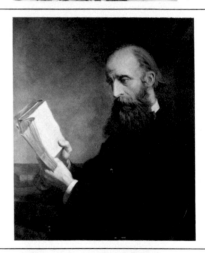

Frederic James Shields
1833–1911

EDWIN GIBBS
Manchester philanthropist

Oil on canvas
76×63 ($29\frac{15}{16} \times 24\frac{13}{16}$)
Unsigned
Gift of the officers, teachers, children
and friends of the Manchester and
Salford Sunday Ragged School Union
(1903.14)

THE GOOD SHEPHERD

Oil on canvas
$164 \times 105 \cdot 8$ ($64\frac{9}{16} \times 41\frac{5}{8}$)
Unsigned
Purchased (1913.17)

THE ANNUNCIATION
1894

Oil on canvas
84·5 × 53·5 (33¼ × 21 1/16)
s(b centre): *F Shields 1894*
Leicester Collier bequest (1917.282)

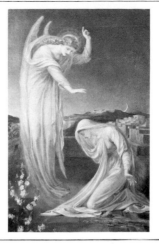

THE WILD SEA'S ENGULFING MAW
(The Gouliot caves, Sark)

Oil on canvas
64 × 78·1 (25 3/16 × 30¾)
s(brc): *F. Shields*
Leicester Collier bequest (1917.287)

LITTLE LAMB, WHO MADE THEE?

Oil on canvas
20·5 × 25·4 (8 1/16 × 10)
Unsigned
Leicester Collier bequest (1917.301)

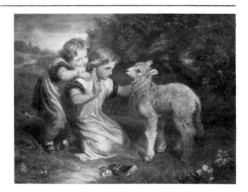

KISS ME, BABY

Oil on canvas
$17\cdot3 \times 20\cdot8$ ($6\frac{13}{16} \times 8\frac{3}{16}$)
s(blc): *F Shields*
Leicester Collier bequest (1917.302)

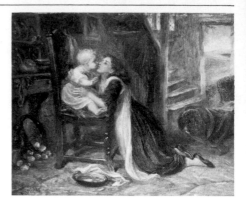

THE WIDOW'S SON

Oil on canvas
$56 \times 65\cdot1$ ($22\frac{1}{16} \times 25\frac{5}{8}$)
Unsigned
Leicester Collier bequest (1917.304)

*Painting awaiting restoration;
no photograph available*

TOUCH ME NOT

Oil on canvas
$30\cdot1 \times 55\cdot7$ ($11\frac{13}{16} \times 21\frac{15}{16}$)
s(blc): *F. Shields*
Leicester Collier bequest (1917.305)

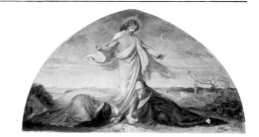

WILLIAM BLAKE'S ROOM
(3 Fountain Court, Strand)
?1882

Oil on canvas
30·5 × 39·5 (12 × 15 $\frac{9}{16}$)
s(brc): *F. Shields. 1882*(?)
Leicester Collier bequest (1917.675)

Frederick Smallfield
1829–1915

EARLY LOVERS
(formerly called FIRST LOVE)
1858

Oil on canvas
76·4 × 46·1 (30 $\frac{1}{16}$ × 18 $\frac{1}{8}$)
s(brc): *Smallfield/1858*
Purchased (1903.1)

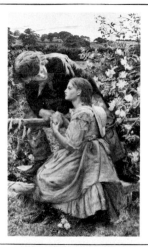

Colvin Smith
See Sir John Watson Gordon

James H. Smith
active ?1783

SIR THOMAS EGERTON, BART., AS AN
ARCHER IN HEATON PARK (1749–1814)
(later 1st Earl of Wilton)
?1783

Oil on canvas
228·6 × 147·3 (90 × 58)
s(brc): *James H. Smith pinx 178*(3?)
Purchased (1958.54)

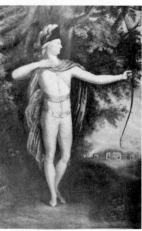

Thomas Smith

d.1767
(formerly attributed to Richard
Wilson)

VIEW FROM DURDHAM DOWN, NEAR
BRISTOL

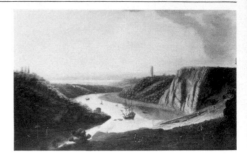

Oil on canvas
$70 \times 109 \cdot 3 \ (27\frac{9}{16} \times 43\frac{1}{16})$
Unsigned
Mrs T. T. Greg gift (1919.10)

Simeon Solomon

1840–1905

STUDY: MALE FIGURE
1878

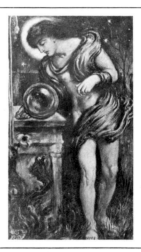

Oil on paper
$32 \times 18 \cdot 1 \ (12\frac{5}{8} \times 7\frac{1}{8})$ sight
s(blc): *SS/1878*
Guy Knowles gift (1933.71)

Richard Gay Somerset

1848–1928

ON THE ELWY, DENBIGHSHIRE

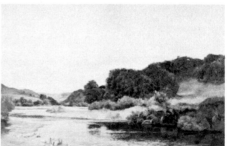

Oil on canvas
$65 \cdot 7 \times 101 \cdot 5 \ (25\frac{7}{8} \times 40)$
s(blc): *R.G. Somerset*
Purchased (1883.20)

CONWAY QUAY
exh. 1889

Oil on canvas
$76 \cdot 1 \times 114 \cdot 2$ ($29\frac{15}{16} \times 44\frac{15}{16}$)
s(blc): *R G Somerset*
William Rothwell bequest (1896.16)

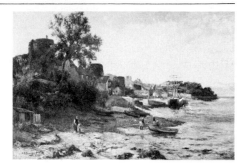

EVENING

Oil on canvas
$35 \cdot 4 \times 55$ ($13\frac{15}{16} \times 21\frac{5}{8}$)
s(brc): *R G Somerset*
William Rothwell bequest (1896.17)

A SURREY PASTORAL
(near Milford, Surrey)
1878

Oil on canvas
$61 \times 120 \cdot 9$ ($24 \times 47\frac{5}{8}$)
s(brc): *R.G. Somerset/78*
Joseph Broome gift (1904.11)

John Souch
active 1616–1636

SIR THOMAS ASTON AT THE DEATHBED
OF HIS WIFE
1635

Oil on canvas
203·2 × 215·1 (80 × 84$\frac{11}{16}$)
s(b centre): *Jo: Souch/Cestren*(s)/*Fecit*
Peter Jones gift through the
N.A-C.F. (1927.150)

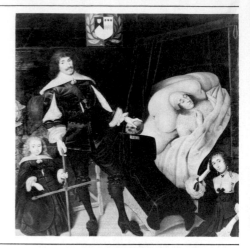

William Clarkson Stanfield
1793–1867

AFTER THE WRECK
(also called A SHIPWRECK)
1853

Oil on canvas
83·5 × 121·5 (32$\frac{15}{16}$ × 47$\frac{7}{8}$)
s(brc): *C. Stanfield. RA. 1853.* (mon)
Lloyd Roberts bequest (1920.532)

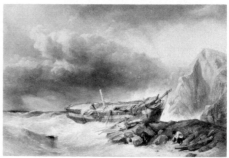

John Roddam Spencer Stanhope
1829–1908

EVE TEMPTED
exh. 1877

Tempera on panel
161·2 × 75·5 (63$\frac{7}{16}$ × 29$\frac{3}{4}$)
Unsigned
John Slagg M.P. gift (1883.29)

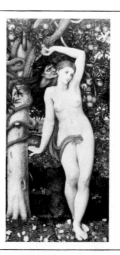

THE WATERS OF LETHE BY THE
PLAINS OF ELYSIUM
exh. 1880

Tempera and gold paint on canvas
147·5 × 282·4 (58 $\frac{1}{16}$ × 111 $\frac{1}{8}$)
Unsigned
Gift of the artist (1889.4)

James Stark
1794–1859

LANDSCAPE IN NORFOLK

Oil on canvas
52·1 × 70·5 (20 $\frac{1}{2}$ × 27 $\frac{3}{4}$)
Unsigned
Purchased (1903.6)

LANDSCAPE WITH A PATH BETWEEN
COTTAGES

Oil on panel
17·4 × 21·5 (6 $\frac{7}{8}$ × 8 $\frac{7}{16}$)
Unsigned
James Blair bequest (1917.152)

A BARGE ON THE YARE: SUNSET

Oil on panel
$26 \cdot 8 \times 36 \cdot 5$ ($10\frac{9}{16} \times 14\frac{3}{8}$)
Unsigned
James Blair bequest (1917.161)

Frank Stone
1800–1859

SELF-PORTRAIT

Oil on canvas
$77 \times 63 \cdot 3$ ($30\frac{5}{16} \times 24\frac{15}{16}$)
Unsigned
Miss Esther Wright gift (1893.19)

Henry Stone
See after Edward Bower

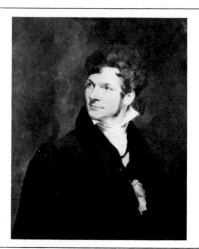

Marcus Stone
1840–1921

THE LOST BIRD
1883

Oil on canvas
$108 \cdot 2 \times 56$ ($42\frac{5}{8} \times 22\frac{1}{16}$)
s(blc): *MARCUS STONE/1883*
Purchased (1884.14)

REVERIE
1899

Oil on canvas
$76 \cdot 5 \times 51$ $(30\frac{1}{8} \times 20\frac{1}{16})$
s(brc): *MARCUS STONE/99*
James Blair bequest (1917.231)

'TWO'S COMPANY, THREE'S NONE'
exh. 1892

Oil on panel
$31 \cdot 1 \times 51 \cdot 6$ $(12\frac{1}{4} \times 20\frac{5}{16})$
s(blc): *MARCUS STONE*
James Blair bequest (1917.196)

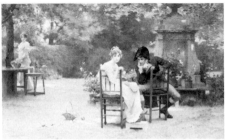

A GIRL IN A GARDEN
1879

Oil on canvas
$51 \times 25 \cdot 5$ $(20\frac{1}{16} \times 10\frac{1}{16})$
s(blc): *MARCUS STONE 1879*
James Blair bequest (1917.198)

A PASSING CLOUD
exh. 1891

Oil on panel
24·7 × 40 (9¾ × 15¾)
s(blc): *MARCUS STONE*.
James Blair bequest (1917.209)

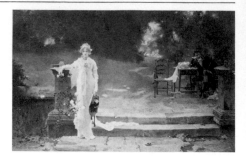

Attributed to Robert Streater
1624–1680

BRANCEPETH CASTLE AND THE
CHURCH OF ST. BRANDON, COUNTY
DURHAM

Oil on canvas
79·5 × 116 (31¼ × 45 11/16)
Unsigned
Purchased (1967.269)

John Melhuish Strudwick
1849–1937

WHEN APPLES WERE GOLDEN AND
SONGS WERE SWEET
BUT SUMMER HAD PASSED AWAY
exh. 1906

Oil on canvas
76·4 × 48·4 (30 1/16 × 19 1/16)
Unsigned
Purchased (1906.103)

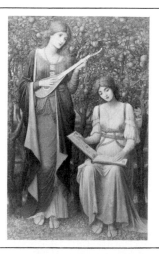

George Stubbs
1724–1806

CHEETAH AND STAG WITH TWO
INDIANS
*c.*1765

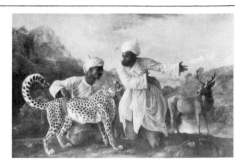

Oil on canvas
180·7 × 273·3 (71⅛ × 107⅝) Unsigned
Purchased from the Art Fund with
grants from H.M. Treasury, through
the Victoria & Albert Museum, and
from the N.A-C.F., Eugene Cremetti
Fund (1970.34)

George Stubbs
See also English School, late 18th
century

John Macallan Swan
1847–1910

MISS ALEXANDRA IONIDES
*c.*1902

Oil on canvas
183·2 × 76·4 (72⅛ × 30 1/16)
s(brc): *John M.SWAN*
Mrs A. C. Ionides gift (1934.484)

Annie Louisa Swynnerton (née Robinson)
1844–1933

THE REV. WILLIAM GASKELL (1805–
1884)
Unitarian minister
1879

Oil on canvas
86·6 × 71·1 (34⅛ × 28)
s(tl): *ALR* (mon)
Inscr(tr): *GVLIELMVS GASKELL/
AETAT LXXIII/MDCCCLXXIX*
Miss M. E. Gaskell bequest (1914.1)

MRS A. SCOTT-ELLIOT AND CHILDREN
1912

Oil on canvas, circular
diameter 148·6 (58½)
s(br): *Annie L Swynnerton/1912*
Purchased (1923.38)

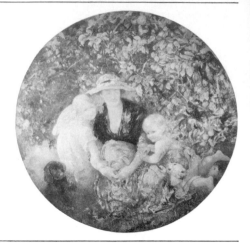

THE SOUTHING OF THE SUN
(Nemi, Italy)
1911

Oil on canvas
111·9 × 88·9 (44 $\frac{1}{16}$ × 35)
s(brc): *Annie L. Swynnerton/1911*
Purchased (1923.47)

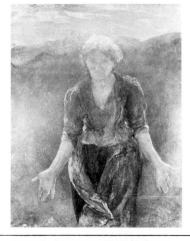

S. ISABEL DACRE (1844–1933)
Artist
1880

Oil on canvas
70·3 × 51·9 (27 $\frac{11}{16}$ × 20 $\frac{7}{16}$)
s(brc): *Annie L. Robinson/1880*
Inscr(tlc): *A mon amie/S. Isabel Dacre*
S. Isabel Dacre gift (1932.15)

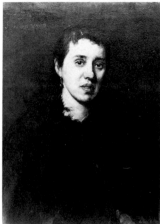

ADORATION OF THE INFANT CHRIST
(after Perugino)

Oil on panel, arched top
59·7 × 90·6 (23½ × 35 11/16)
Unsigned
Bequest of the artist (1934.12)

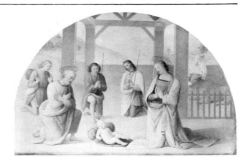

MONTAGNA MIA
exh. 1923

Oil on canvas
112·3 × 183 (44 3/16 × 72 1/16)
Unsigned
Bequest of the artist (1934.13)

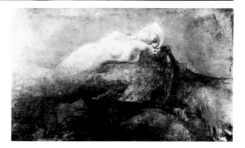

THE VAGRANT
exh. 1922

Oil on canvas
74 × 59·4 (29 1/8 × 23 3/8)
Unsigned
Bequest of the artist (1934.14)

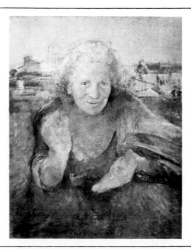

RAIN-CLOUDS, MONTE GENNARO
1904

Oil on canvas
30·6 × 63 ($12\frac{1}{16}$ × $24\frac{13}{16}$)
s(brc): *Annie L. Swynnerton/1904*
Mrs L. M. Garrett bequest (1936.206)

ILLUSIONS

Oil on canvas
68 × 51 ($26\frac{3}{4}$ × $20\frac{1}{16}$)
Unsigned
Mrs L. M. Garrett bequest (1936.207)

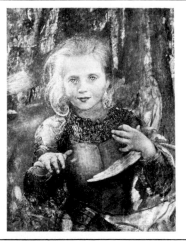

AN ITALIAN MOTHER AND CHILD
1886

Oil on canvas
125·8 × 73·5 ($49\frac{1}{2}$ × $28\frac{15}{16}$)
s(brc): *Annie L. Robinson/Roma 1886*
Mrs L. M. Garrett bequest (1936.208)

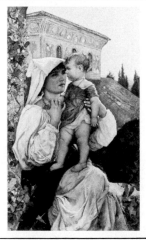

THE TOWN OF SIENA

Oil on canvas
$37 \cdot 8 \times 51$ ($14\frac{7}{8} \times 20\frac{1}{16}$)
s(brc): *Annie L Swynnerton*
Mrs L. M. Garrett bequest (1936.210)

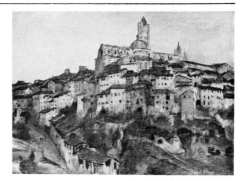

INTERIOR OF SAN MINIATO, FLORENCE
1881

Oil on canvas
$26 \times 30 \cdot 4$ ($10\frac{1}{4} \times 12$)
s(brc): *Annie L. Robinson/Florence.
1881.*
Mrs L. M. Garrett bequest (1936.211)

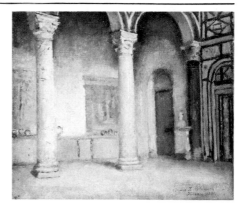

CROSSING THE STREAM
(unfinished)

Oil on canvas
$126 \cdot 2 \times 74$ ($49\frac{11}{16} \times 29\frac{1}{8}$)
Unsigned
Mrs L. M. Garrett bequest (1936.212)

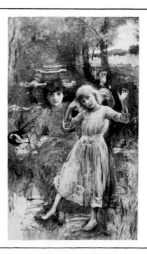

THE DREAMER
1887

Oil on canvas
$53·3 \times 42·8$ ($21 \times 16\frac{7}{8}$)
s(brc): *Annie L. Robinson/1887*
Mrs F. R. Wilkinson gift (1936.267)

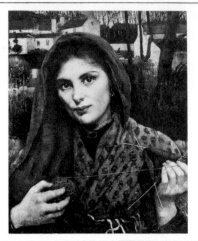

THE OLIVE GATHERERS
(also called THE PLAIN OF LOMBARDY)
1889

Oil on canvas
$38·5 \times 71$ ($15\frac{1}{8} \times 27\frac{15}{16}$)
s(brc): *Annie L. Swynnerton 1889*
Miss F. R. Wilkinson gift (1936.268)

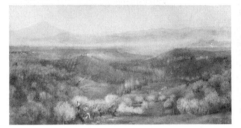

ITALIAN LANDSCAPE

Oil on canvas
$84·3 \times 119·1$ ($33\frac{3}{16} \times 46\frac{7}{8}$)
s(br): *Annie L. Swynnerton*
Dr Jane Walker bequest (1939.20)

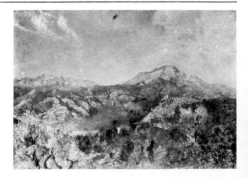

John F. Tennant
1796–1872

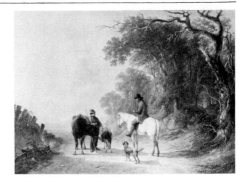

THE OLD SQUIRE
1838

Oil on canvas
$89 \times 124 \cdot 4$ $(35 \times 48\frac{15}{16})$
s(blc): *J. Tennant Oct/1838*
Transferred from the Horsfall
Museum (1918.404)

Elizabeth Thompson
See Lady Elizabeth Butler

Rev. John Thomson of Duddingston
1778–1840

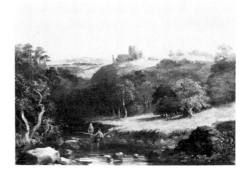

CRAIGMILLAR CASTLE
(near Edinburgh)

Oil on canvas
46×61 $(18\frac{1}{8} \times 24)$
Unsigned
Mrs Roger Oldham gift (1916.5)

John Thomson
active 1863–1872

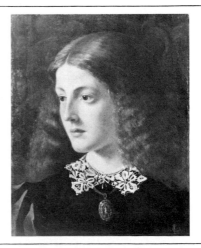

STUDY OF A HEAD
1863

Oil on canvas
$37 \cdot 5 \times 29 \cdot 5$ $(14\frac{3}{4} \times 11\frac{5}{8})$
s(brc): *18 JT 63* (mon)
Thomas Armstrong gift (1906.101)

Sir James Thornhill
1675–1734

TIME, TRUTH AND JUSTICE
*c.*1716

Oil on canvas
24·5 × 48·5 (9⅝ × 19⅛)
Unsigned
Purchased (1964.57)

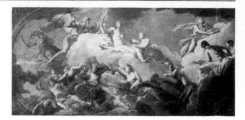

TIME, PRUDENCE AND VIGILANCE
*c.*1716

Oil on canvas
24·5 × 48·5 (9⅝ × 19⅛)
Unsigned
Purchased (1964.58)

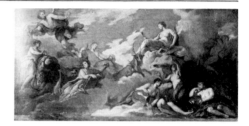

THE VICTORY OF APOLLO
(also called ASSEMBLY OF THE GODS)
*c.*1716

Oil on canvas
24·5 × 48·5 (9⅝ × 19⅛)
Unsigned
Purchased (1964.59)

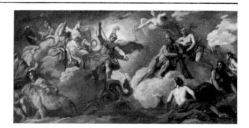

James (Jacques Joseph) Tissot
1836–1902

A CONVALESCENT

Oil on panel
$36 \cdot 2 \times 21 \cdot 8$ ($14\frac{1}{4} \times 8\frac{11}{16}$)
s(brc): *J J Tissot*
Purchased (1925.47)

HUSH!
(also called THE CONCERT)
exh. 1875

Oil on canvas
$73 \cdot 7 \times 112 \cdot 2$ ($29 \times 44\frac{3}{16}$)
s(brc): *J.J. Tissot*
Purchased (1933.56)

Henry Tresham
1751–1814

THE EARL OF WARWICK'S VOW
PREVIOUS TO THE BATTLE OF TOWTON
(1461)
exh. 1797

Oil on canvas
$44 \times 35 \cdot 8$ ($17\frac{5}{16} \times 14\frac{1}{8}$)
Unsigned
Purchased (1966.334)

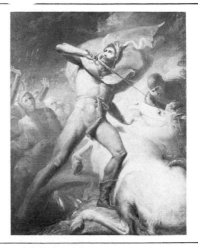

F. C. Turner
active 1810–1846

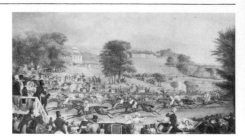

HEATON PARK RACES, MANCHESTER

Oil on canvas
34·4 × 62·3 ($13\frac{9}{16} \times 24\frac{9}{16}$)
Inscr(bl): *Painted by/...* (illegible)
J. T. Malpass bequest (1931.17)

Joseph Mallord William Turner
1775–1851

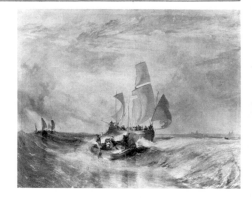

'NOW FOR THE PAINTER' (ROPE) –
PASSENGERS GOING ON BOARD
(also called PAS DE CALAIS)
1827

Oil on canvas
174·3 × 213·8 ($68\frac{5}{8} \times 84\frac{3}{16}$)
Unsigned
F. J. Nettlefold gift (1947.507)

J. M. W. Turner
See also English School, early 19th
century

Thomas Uwins
1782–1857

ITALIAN PEASANTS
1850

Oil on panel
55 × 41·7 ($21\frac{5}{8} \times 16\frac{3}{8}$)
s(blc): *T. UWINS.RA./1850*
Sir Joseph Whitworth bequest (1896.6)

John Vanderbank
?1694–1739

SCENE FROM 'DON QUIXOTE': THE
ARRIVAL AT THE SUPPOSED CASTLE
*c.*1730–6

Oil on panel
40·7 × 29·6 (16 × 11⅝)
Unsigned
Purchased (1967.224)

SCENE FROM 'DON QUIXOTE': ZORAIDA
PRETENDING TO SWOON IN THE
GARDEN
?1730

Oil on panel
40 × 28·6 (15¾ × 11¼)
s(blc): *J. Vanderbank. Fecit. 1730*(?)
Purchased (1967.225)

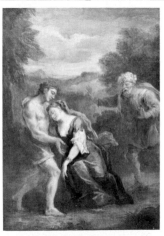

Alfred Vickers
1768–1868

THIRLMERE, CUMBERLAND

Oil on canvas
18·1 × 26 (7⅛ × 10¼)
Unsigned
Gift of the Executors of J. R. Oliver
(1934.438)

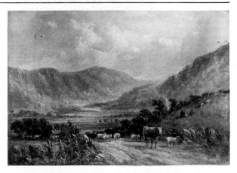

George Vincent
1796–1836

VIEW NEAR WROXHAM, NORFOLK

Oil on canvas
49·1 × 38·8 (19 $\frac{5}{16}$ × 15 $\frac{5}{16}$)
Unsigned
Purchased (1904.10)

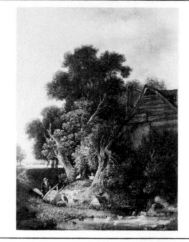

WOODED LANDSCAPE WITH FIGURES
AND GATE

Oil on panel
27·8 × 35·5 (10 $\frac{15}{16}$ × 14)
Unsigned
Alderman R. A. D. Carter bequest
(1938.51)

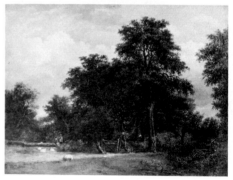

John Barton Waddington
?1835–m. 1857

VIEW OF MANCHESTER FROM KERSAL
1856

Oil on millboard
17·6 × 27·8 (6 $\frac{15}{16}$ × 10 $\frac{15}{16}$)
s(br): *John B. Waddington.Sep. 1856.*
Purchased (1927.42)

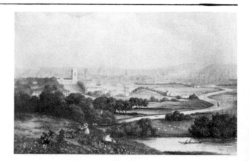

Robert Thorne Waite
1842–1935

NEW MOWN HAY

Oil on canvas
99·1 × 135 (39 × 53⅛)
s(brc): *Thorne Waite*
Purchased (1901.10)

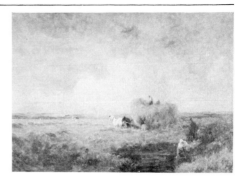

Edward Mathew Ward
1816–1879

BYRON'S EARLY LOVE, 'A DREAM OF
ANNESLEY HALL'
1856

Oil on canvas
62 × 51·3 (24⅜ × 20³⁄₁₆)
s(brc): *E M Ward RA/1856*
Sir Charles E. Swann gift (1917.273)

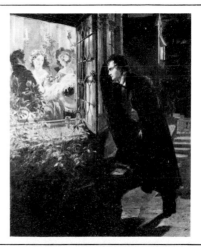

John William Waterhouse
1849–1917

HYLAS AND THE NYMPHS
1896

Oil on canvas
98·2 × 163·3 (38¹¹⁄₁₆ × 64¼)
s(blc): *J. W. Waterhouse /1896*
Purchased (1896.15)

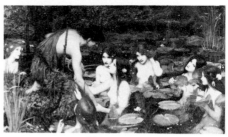

John Dawson Watson
1832–1892

INSPIRATION
1866

Oil on panel
$30 \cdot 4 \times 24 \cdot 9$ ($11\frac{15}{16} \times 9\frac{13}{16}$)
s(blc): *J. D. W. 1866*
Leicester Collier bequest (1917.317)

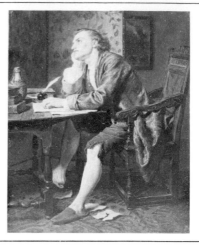

George Frederick Watts
1817–1904

THE GOOD SAMARITAN
1852

Oil on canvas
$254 \cdot 7 \times 189 \cdot 2$ ($100\frac{1}{4} \times 74\frac{1}{2}$)
s(br): *G.F.Watts. 1852*
Transferred from the Royal
Manchester Institution (1882.149)

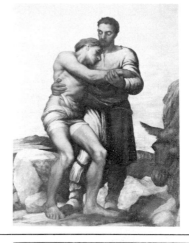

CHARLES HILDITCH RICKARDS (d. 1886)
Philanthropist; chairman of the
Manchester Board of Guardians
1866

Oil on canvas
$82 \cdot 8 \times 67 \cdot 4$ ($32\frac{5}{8} \times 26\frac{1}{2}$)
s(blc): *G F. Watts./1866.*
Inscr(brc): *Mr C.H. Rickards.*
Gift of the Executors of
C. H. Rickards (1886.9)

MAY PRINSEP
(also called PRAYER)
1867

Oil on canvas
102·6 × 69·6 (40⅜ × 27⅜)
Unsigned
Purchased (1887.10)

THE COURT OF DEATH
(also called THE ANGEL OF DEATH)
1863–4

Oil on canvas
381 × 259 (150 × 102) approx.
Unsigned
Gift of the artist through T. C.
Horsfall (1900.23)

*Painting awaiting restoration;
no photograph available*

THE HON. JOHN LOTHROP MOTLEY
(1814–1877)
American historian
1861

Oil on panel
60·8 × 50·1 (23¹⁵⁄₁₆ × 19¾)
s(blc): *G F Watts.*
Purchased (1906.99)

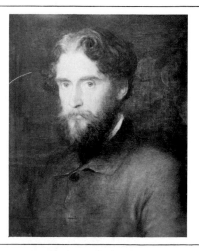

PAOLO AND FRANCESCA
(from Dante's 'Inferno')
1870

Oil on canvas
$66 \cdot 1 \times 52 \cdot 5$ $(26 \times 20\frac{5}{8})$
s(blc): *G.FW. 1870*
Purchased (1907.7)

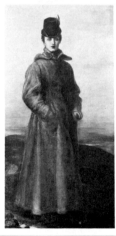

THE ULSTER
Mrs. Andrew Hichens, née May
Prinsep
1874

Oil on canvas
$198 \cdot 7 \times 99 \cdot 7$ $(78\frac{1}{4} \times 39\frac{1}{4})$
Unsigned
Presented by the daughters of C. W.
and M.C. Carver in memory of their
great-uncle Charles Rickards (1922.30)

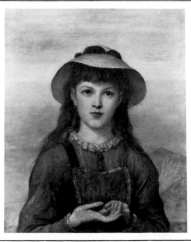

STUDY: HEAD OF A GIRL
1876

Oil on canvas
$66 \times 53 \cdot 1$ $(26 \times 20\frac{7}{8})$
s(blc): *G.F.W./1876*
John E. Yates bequest (1934.405)

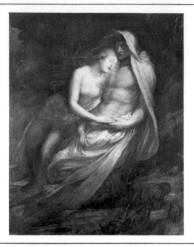

A GREEK IDYLL
(also called ACIS AND GALATEA)
1894

Oil on canvas
$91 \times 125 \cdot 7$ $(35\frac{13}{16} \times 49\frac{1}{2})$
s(blc): *G.F. Watts/1894*
John E. Yates bequest (1934.412)

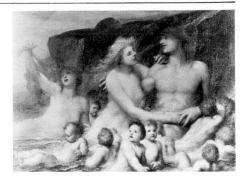

THE COQUETTE
*c.*1880

Oil on canvas
$66 \cdot 2 \times 53 \cdot 4$ $(26\frac{1}{16} \times 21)$
s(brc): *G F Watts*
G. Beatson Blair bequest 1941
(1947.129)

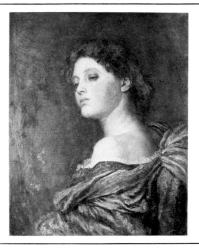

James Webb
1837–1895

FISHING ON A SQUALLY DAY
1861

Oil on canvas
$92 \cdot 5 \times 153 \cdot 6$ $(36\frac{3}{8} \times 60\frac{1}{2})$
s(blc): *James Webb 1861*
Anonymous gift (1920.1346)

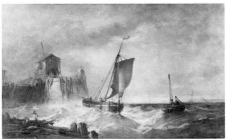

AFTER THE STORM
(off Mont Orgueil and Gorey, Jersey)

Oil on canvas
$77 \cdot 2 \times 115$ $(30\frac{3}{8} \times 45\frac{1}{4})$
s(on boat, centre): *James Webb/Jersey*
R. F. Goldschmidt gift (1932.86)

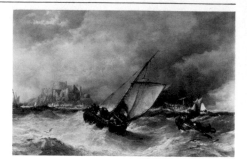

CONSTANTINOPLE

Oil on canvas
$61 \cdot 3 \times 91 \cdot 7$ $(24\frac{1}{8} \times 36\frac{1}{4})$
s(right, on boat): *James Webb*
John E. Yates bequest (1934.409)

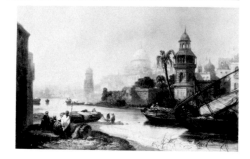

William Edward Webb
d. 1903

DOUGLAS HARBOUR, ISLE OF MAN

Oil on canvas
$35 \cdot 6 \times 30$ $(14 \times 11\frac{13}{16})$
s(blc): *W.E.WEBB*
F. E. Simpson gift (1966.626)

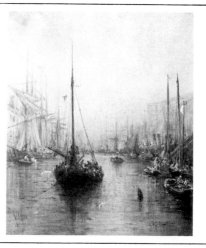

William J. Webb
active 1853–1878

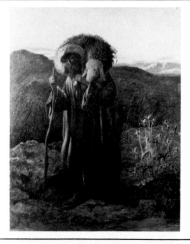

THE LOST SHEEP
1864

Oil on panel
$33\cdot1\times25\cdot1$ $(13\frac{1}{16}\times9\frac{7}{8})$
s(brc): *18 WJW 64* (mon)
Purchased (1920.94)

Richard Westall
1765–1836

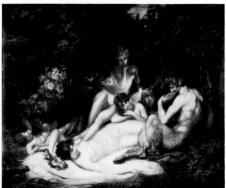

THE BOWER OF PAN
exh. 1800

Oil on canvas
$88\cdot5\times106\cdot2$ $(34\frac{7}{8}\times41\frac{13}{16})$
Unsigned
Purchased (1971.91)

Philip Westcott
1815–1878

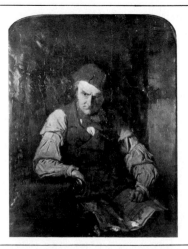

COGITATING THE POOR-LAW BILL
(also called STUDYING THE POOR-LAW)
exh. 1844

Oil on canvas
$69\cdot4\times45\cdot8$ $(23\frac{3}{4}\times18)$
Unsigned
Transferred from the Horsfall
Museum (1918.417)

GEORGE CORNWALL LEGH, M.P.
(1804–1877)
engr. 1850

Oil on canvas
142·5 × 111·7 (56⅛ × 44)
Unsigned
Thomas Agnew & Sons gift (1967.109)

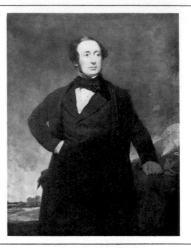

Henry Clarence Whaite
1828–1912

THE HEART OF CAMBRIA
1886

Oil on canvas
190·3 × 122·2 (74 15/16 × 48⅛)
s(blc): *H. Clarence Whaite/Aug. 1886*
Purchased (1886.6)

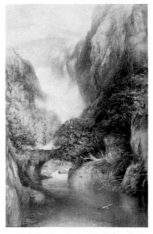

LLYN DYLUN, THE LLANDUDNO
WATER SUPPLY
exh. 1898

Oil on canvas
55·3 × 78·3 (21¾ × 30 13/16)
s(blc): *H. Clarence Whaite*
Purchased (1898.9)

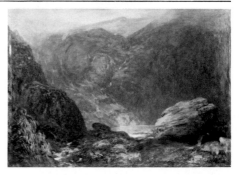

JUST ARRIVED BY THE SLOOP
(in the Conway Valley, North Wales)
1889

Oil on canvas
86·3 × 152·6 (34 × 60 $\frac{1}{16}$)
s(blc): *H. Clarence Whaite/1889*
Frederick Smallman gift (1908.8)

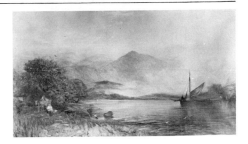

Francis Wheatley
1747–1801

A SCENE IN TWELFTH NIGHT, ACT 3
(The duel, from Shakespeare's
'Twelfth Night' III, 4)
1771–2

Oil on canvas
99·8 × 124·8 (39 $\frac{1}{4}$ × 49 $\frac{1}{8}$)
Unsigned
Purchased (1953.4)

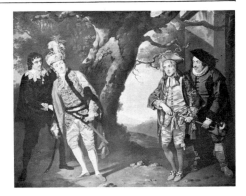

Samuel De Wilde
1747–1832

MUSIC
1801

Oil on canvas
71·1 × 90·7 (28 × 35 $\frac{3}{4}$)
s(bl on a base of putto): *S. de Wilde.*
Pinx 1801
Purchased (1910.8)

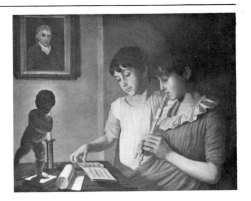

Sir David Wilkie
1785–1841

SIR ALEXANDER KEITH
(d. 1832)
(at the visit of George IV to Holyrood
House, Edinburgh in 1822)

Oil on panel
$71 \cdot 8 \times 48 \cdot 3$ ($28\frac{1}{4} \times 19$)
s(b centre): *David Wilkie 1830*
Purchased with a grant from the
Victoria and Albert Museum
(1972.53)

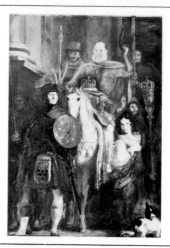

John Haynes Williams
1836–1908

SPANISH DANCER
1873

Oil on canvas
$70 \cdot 5 \times 91$ ($27\frac{3}{4} \times 35\frac{13}{16}$)
s(br): *Haynes Williams 1873*
Horsfall Museum transfer (1918.1154)

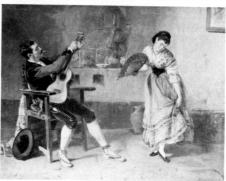

Alexander Wilson
1803–1846

A HORSE IN PLATT FIELDS,
MANCHESTER, WITH PLATT HALL IN
THE DISTANCE
1822

Oil on canvas
$71 \cdot 8 \times 86 \cdot 4$ ($28\frac{1}{4} \times 34$)
s(bl): *A. Wilson.–/1822*
Mrs Clementia Tindal-Carill-Worsley
gift (1963.297)

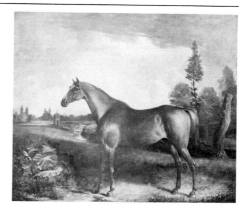

Benjamin Wilson
See English School, *c.*1770

Richard Wilson
1714–1782

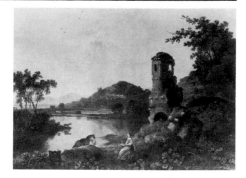

CICERO'S VILLA
(formerly called ON THE STRADA
NOMENTANA)
?1760/63

Oil on canvas
101·3 × 136·8 (39⅞ × 53⅞)
Unsigned
Purchased (1897.1)

LANDSCAPE WITH RUINED CASTLE
OVERLOOKING A RIVER
(also called LANDSCAPE WITH RUINS;
or WELSH LANDSCAPE WITH A RUINED
CASTLE)

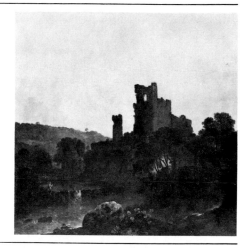

Oil on canvas
169·5 × 163·5 (66¾ × 64⅜)
Unsigned
Purchased (1903.5)

VALLEY OF THE MAWDDACH
(also called A WELSH VALLEY)

Oil on canvas
91·7 × 106·7 (36⅛ × 42)
Unsigned
Purchased (1905.21)

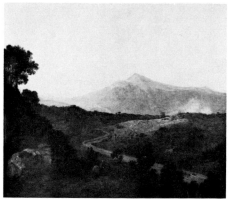

HADRIAN'S VILLA
(formerly called ON THE STRADA
NOMENTANA)

Oil on canvas
$42 \cdot 8 \times 52 \cdot 9$ ($16\frac{7}{8} \times 20\frac{13}{16}$)
Unsigned
James Blair bequest (1917.175)

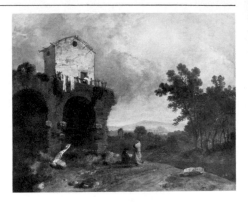

RIVER VIEW (ON THE ARNO) III
1764

Oil on canvas
$123 \cdot 5 \times 105 \cdot 9$ ($48\frac{5}{8} \times 41\frac{11}{16}$)
s(bl): *RW 1764* (mon)
Purchased with grants from the
N.A-C.F. and the Victoria and
Albert Museum (1969.182)

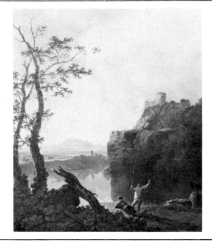

Follower of Richard Wilson

RIVER VIEW (ON THE ARNO) II
(also called ITALIAN LANDSCAPE)

Oil on canvas, circular
$69 \cdot 1 \times 68 \cdot 7$ ($27\frac{3}{16} \times 27\frac{1}{16}$)
Unsigned
Purchased (1909.14)

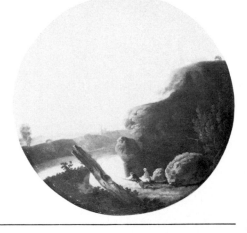

After Richard Wilson

PEMBROKE CASTLE

Oil on canvas
$62 \cdot 2 \times 89 \cdot 5$ ($24\frac{1}{2} \times 35\frac{1}{4}$)
Unsigned
Mrs Robert Hatton gift 1908
(1909.38)

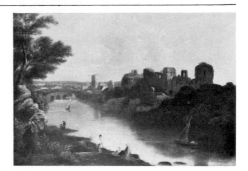

DOLBADARN CASTLE AND LLYN PERIS
(formerly called POZZUOLI FROM
ACROSS THE BAY OF BAIAE)

Oil on canvas
$43 \cdot 2 \times 68 \cdot 5$ (17×27)
Unsigned
Purchased (1924.57)

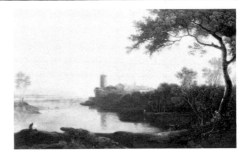

Richard Wilson
See also English School, 18th century;
Thomas Smith; Swiss School (Foreign
Schools Catalogue)

Edmund Morison Wimperis
1835–1900

WATERING HORSES
?1893

Oil on canvas
$70 \cdot 3 \times 108 \cdot 2$ ($27\frac{11}{16} \times 42\frac{9}{16}$)
s(blc): $E\,M\,WIMPER$(IS 93?)
William Rothwell bequest (1896.18)

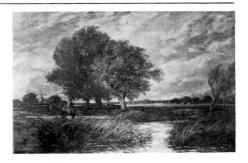

THE FERRY
1894

Oil on canvas
$61 \times 91 \cdot 3$ ($24 \times 35\frac{15}{16}$)
s(blc): *EMW* (mon)
James Gresham bequest (1917.252)

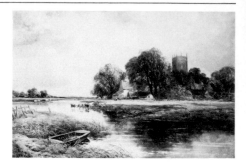

William Lindsay Windus
1823–1907

THE OUTLAW
1861

Oil on canvas, arched top
$35 \cdot 7 \times 34 \cdot 3$ ($14\frac{1}{16} \times 13\frac{1}{2}$)
Unsigned
Sir Thomas D. Barlow gift (1937.28)

SAMUEL TEED

Oil on canvas
$71 \cdot 7 \times 61$ ($28\frac{1}{4} \times 24$)
Unsigned
Major P. L. Teed gift (1954.1058)

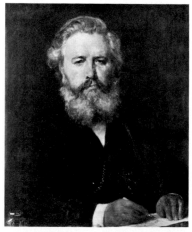

Peter de Wint
1784–1849

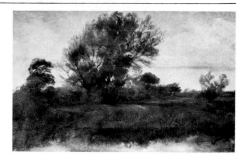

LANDSCAPE WITH WILLOW TREE

Oil on panel
$27 \cdot 5 \times 43 \cdot 3$ ($10\frac{13}{16} \times 17\frac{1}{16}$)
Unsigned
Purchased (1946.164)

(formerly attributed to John Constable)

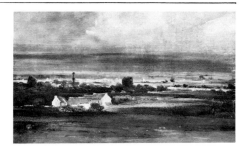

VIEW OVER FLAT COUNTRY

Oil on canvas
$21 \cdot 2 \times 35 \cdot 2$ ($8\frac{3}{8} \times 13\frac{7}{8}$)
Unsigned
G. Beatson Blair bequest 1941
(1947.67)

John Wootton
c.1686–1764

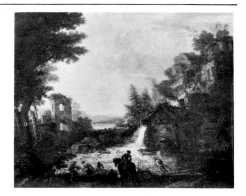

LANDSCAPE WITH FISHERMEN
?1753

Oil on canvas
$98 \cdot 4 \times 120$ ($38\frac{3}{4} \times 47\frac{1}{4}$)
?s(blc): *J. Wootton/1753*
Purchased (1953.111)

Joseph Wright of Derby
1734–1797
(formerly attributed to George
Romney; English School)

A GENTLEMAN CALLED THE HON.
THOMAS BLIGH
c.1777–80

Oil on canvas
75·5 × 63·2 (29¾ × 24⅞)
Unsigned
Purchased (1901.5)

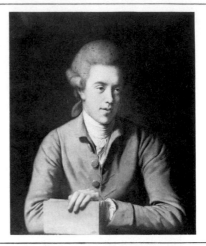

THOMAS DAY (1748–1789)
Philanthropist and writer
1770

Oil on canvas
127 × 100·4 (50 × 39½)
Unsigned
Purchased (1975.194)

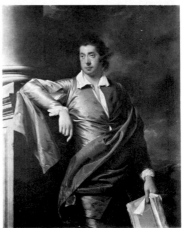

After Joseph Wright of Derby

SIR RICHARD ARKWRIGHT (1732–1792)
Inventor of textile machinery

Oil on canvas
76·5 × 63·8 (30⅛ × 25⅛)
Unsigned
Manchester Royal Exchange gift
(1968.239)

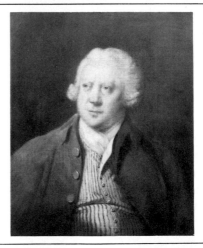

John Michael Wright
1625–1700

MURROUGH O'BRIEN, 1ST EARL OF
INCHIQUIN (1614–1674)
c.1660—70

Oil on canvas
$115\cdot5 \times 106$ ($45\frac{1}{2} \times 41\frac{3}{4}$)
Unsigned
Inscr(tr): *The Right Honbl the/Earl of
Inchequeen*
Sir Thomas Barlow gift (1945.255)

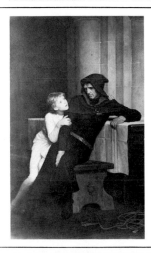

William Frederick Yeames
1835–1918

PRINCE ARTHUR AND HUBERT
1882

Oil on canvas
$201\cdot3 \times 125\cdot8$ ($79\frac{1}{4} \times 49\frac{1}{2}$)
s(blc): *W.F. YEAMES./1882*
Purchased (1883.19)

Johann Zoffany
1733–1810

VENUS BRINGING ARMS TO AENEAS
1759

Oil on canvas
$27\cdot6 \times 37\cdot8$ ($10\frac{7}{8} \times 14\frac{7}{8}$)
s(brc): *Zauffally/1759*
Purchased (1966.4)

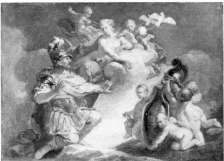

Johann Zoffany
See also Henry Robert Morland

APPENDIX 1

Paintings at the Gallery of English Costume, Platt Hall

William Henry Bellot
1811–1895

JANE HALE (1772–1844)
(m. Thomas Bellot)
c.1836–40

Oil on canvas
76×64 ($29\frac{7}{8} \times 25\frac{1}{4}$)
Unsigned
Professor H. H. Bellot bequest (1969.127)

FRANCES LEIGH KILLER (1820–1903)
(m. W. H. Bellot)
c.1848–50

Oil on canvas
51×39.5 ($20\frac{1}{8} \times 15\frac{1}{2}$)
Unsigned
Professor H. H. Bellot bequest (1969.129)

English School
1789

JOSEPH BELLOT (1765–1849)

Oil on canvas
49×38 ($19\frac{1}{4} \times 15$)
inscr (on a piece of paper held by the
sitter): *Josh Bellot Esq RN/HMS Pegasus/
1789*
(trc): coat of arms (same as in 1969.128,
English School, c.1835–40)
Professor H. H. Bellot bequest (1969.136)

English School
c.1795–1800

THOMAS BARROW

Oil on canvas
35×27.5 ($13\frac{3}{4} \times 10\frac{13}{16}$)
Unsigned
Professor H. H. Bellot bequest (1969.131)

MRS THOMAS BARROW
(née Hardman)

Oil on canvas
35.5×27.5 ($14 \times 10\frac{13}{16}$)
Unsigned
Professor H. H. Bellot bequest (1969.132)

English School
c.1800–1810

THOMAS BELLOT (1766–1826)

Oil on canvas
66×56 ($26 \times 22\frac{1}{16}$)
Unsigned
Professor H. H. Bellot bequest (1969.126)

English School
c.1815

ABRAHAM BELLOT (1779–1885)
Younger son of Anthony Bellot

Oil on canvas
69.5×57.5 ($27\frac{3}{8} \times 22\frac{5}{8}$)
Unsigned
Professor H. H. Bellot bequest (1969.130)

English School
c.1815–25

PETER MADDOX HOLDING A BIRD

Oil on panel
55.4×44 ($21\frac{3}{8} \times 17\frac{5}{16}$)
Unsigned
Manx Museum gift (1964.155)

JOHN MADDOX WITH A CAT

Oil on canvas
56×45.2 ($22 \times 17\frac{3}{4}$)
Unsigned
Manx Museum gift (1964.156)

English School
*c.*1830–40

A MAN WITH HIS RIGHT HAND ON A BOOK

Oil on canvas
43·5 × 35·2 ($17\frac{1}{8}$ × $13\frac{7}{8}$)
Unsigned
Miss B. Ball gift (1962.242/1)

A WOMAN HOLDING A RED BOOK

Oil on canvas
43·5 × 34·5 ($17\frac{1}{8}$ × $13\frac{5}{8}$)
Unsigned
Miss B. Ball gift (1962.242/2)

English School
*c.*1835–40

WILLIAM HENRY BELLOT (1811–1895)

Oil on canvas
55 × 39 ($21\frac{5}{8}$ × $15\frac{3}{8}$)
Unsigned; (blc): coat of arms (same as in
1969.136, English School, 1789)
Professor H. H. Bellot bequest (1969.128)

English School
1847

FRANCES LEIGH KILLER (1820–1903)
(m. W. H. Bellot)

Oil on canvas
27·2 × 20·8 ($10\frac{3}{4}$ × $8\frac{1}{8}$)
Unsigned
Professor H. H. Bellot bequest (1969.135)

APPENDIX 2
Paintings from the collection of the Royal Manchester Institution

The Royal Manchester Institution was founded in 1823. Its collection was transferred to the City of Manchester in 1882 along with the R.M.I. building, to become the present City Art Gallery. This appendix lists firstly the mode and date of acquisition by the R.M.I. of works which fall within the scope of this volume. The other details are given in the body of the catalogue.

Richard Ansdell
THE CHASE
Purchased 1847

James Barry
THE BIRTH OF PANDORA
Purchased 1856

William Etty
THE SIRENS AND ULYSSES
William Grant gift 1839

THE STORM
Purchased 1832

Benjamin Robert Faulkner
ROBERT HINDLEY
Miss Hindley gift 1864

James Astbury Hammersley
MOUNTAINS AND CLOUDS
Gift of the artist 1851

William Hilton
PHAETON
Purchased 1856

George Morland
A FARRIER'S SHOP
John Greaves gift 1834

James Northcote
OTHELLO, THE MOOR OF VENICE
Purchased 1827

Frederick Richard Pickersgill
SAMSON BETRAYED
Purchased 1851

Reuben Sayers
THE WATER LILY
Gift of the artist 1850

George Frederick Watts
THE GOOD SAMARITAN
Gift of the artist to the citizens of Manchester, 1852, as an expression of his admiration for Thomas Wright, the prison philanthropist.

Listed below are items transferred from the R.M.I. which have since been sold or written off.

William Hilton
HEROD
Provenance unknown. Written off

William Hodges
THE ANGEL APPEARING TO HAGAR
Charles O'Neil gift 1830. Written off

Philip Hoyoll
A BREAD RIOT IN GERMANY
Gift of the artist 1859. Sold 1931

J. S. Lauder
FERDINAND AND MIRANDA PLAYING CHESS IN PROSPERO'S CELL
Purchased 1848. Destroyed 1931

James Northcote
JOHN BALIOL SURRENDERING HIS CROWN TO EDWARD I OF ENGLAND
J. W. Barton gift 1836. Sold 1931
See Appendix 3

Sebastian Pether Jr.
THE ERUPTION OF MOUNT VESUVIUS BY
MOONLIGHT
Gift of the artist 1826. Destroyed 1931

William Small
THE WRECK
Samuel Pope gift 1900. Destroyed 1931
See Appendix 3

John Tennant
TWILIGHT
Gift of the artist 1851. Sold 1931

Henry Tresham
THE MAID OF KENT
J. W. Barton gift 1836. Sold 1931

Richard Westall
POPE LEO IV ANOINTING ALFRED THE
GREAT
Samuel Green gift 1831/2. Destroyed 1931
See Appendix 3

Francis Wheatley
SCENE FROM 'ALL'S WELL THAT ENDS
WELL'
James Beardoe gift 1828. Sold 1931

APPENDIX 3

Pictures no longer in the collection, but which were in the 1910 'Handbook to the Permanent Collection'

The Handbook entry numbers are given first. Signatures were not recorded in the Handbook.

284 James Northcote
1746–1831

JOHN BALIOL SURRENDERING HIS
CROWN TO EDWARD I OF ENGLAND,
A.D.1296

Before 1807
Oil on canvas
7ft 4½in. × 5ft 4½in.
J. W. Barton gift 1836
Transferred from the Royal
Manchester Institution (1882.13)
Sold 1931

358 William Small
b.1843; active 1869–1900

THE WRECK
?exh. 1876

Oil on canvas
6ft 6in. × 4ft 10 in.
Samuel Pope gift (1900.17)
Destroyed 1931

434 Richard Westall
1765–1836

POPE LEO IV ANOINTING ALFRED THE
GREAT
Before 1807

Oil on canvas
7 ft 1½ in. × 5 ft 5 in.
Samuel Green gift 1831/2
Transferred from the Royal
Manchester Institution (1882.15)
Destroyed 1931

The following works were included in the 1910 Handbook without it being stated that they were on loan from the National Gallery:

237 John Martin
THE DESTRUCTION OF POMPEII AND
HERCULANEUM
(Damaged in Tate Gallery flood)

287 John Opie
TROILUS, CRESSIDA AND PANDARUS
(Now at Tate Gallery)

APPENDIX 4

Index of Portraits

APPENDIX 5

Index of Donors